THIS IS SERIOUS:
CANADIAN INDIE COMICS

THIS IS
CANADIAN

SERIOUS: INDIE COMICS

THIS IS SERIOUS:
CANADIAN INDIE COMICS

ART GALLERY OF HAMILTON

CURATED BY
ALANA TRAFICANTE
& JOE OLLMANN

TABLE OF CONTENTS

DIRECTOR'S FOREWORD

SHELLEY FALCONER

Growing up in French schools in Canada, my siblings and I read, collected and consumed the Franco-Belgian classic texts *Asterix* and *Tintin* with insatiable appetites. Widely recognized as "suitable" literature, they stood out against American comics, which had to be hidden under beds and behind bookshelves from parents and teachers. As I moved through my academic years, comics surfaced as an important medium of influence and appropriation in the canons of art history and cultural studies, from Pop art to the contemporary, but remained marginalized as a genre, both academically and institutionally.

Beginning in 1967 in Paris with the Louvre's exhibition *Bande dessinée et figuration narrative* at the Musée des Arts Décoratifs, museums and galleries started to recognize comics as an art form. The Museum of Modern Art's popular *High and Low: Modern Art and Popular Culture* in 1990–91 is often cited as a turning point, though comics played only a small part in that exhibition. The 2005–6 joint exhibition by the Los Angeles Museum of Contemporary Art and the Hammer Museum, *Masters of American Comics*, gave comics centre stage at last. While these exhibitions resonated internationally, in Canada a new generation of artists—also influenced by a steady diet of *Asterix*, *Tintin* and American comics, graphic novels and Japanese manga—was beginning to develop a distinctive field of creative endeavour. And yet, as Jeet Heer notes, "Cartooning in Canada has always been a matter of survival on the margins."

The Art Gallery of Hamilton is proud to present Canada's first retrospective of Canadian comics. *THIS IS SERIOUS: Canadian Indie Comics* begins with a nod to the historical roots of Canadian cartooning in the 1950s through the 1970s, featuring a number of mainstream newspaper and magazine cartoonists such as Blaine, Doug Wright and James Simpkins. Next, it celebrates the recognition of celebrated graphic cartoonists and writers such as Chester Brown, Seth, Julie Doucet and Fiona Smyth. With forty-seven artists represented from across Canada, including rising stars, exhibition curators Alana Traficante and Joe Ollmann provide insight into a full range of the genre's visual and narrative themes, navigating issues that touch on labour history, feminism, queer theory, decolonization and more.

THIS IS SERIOUS: Canadian Indie Comics has been a shared passion for the curators and the many artists they collaborated with and present here. Looking through a macroscopic lens, Traficante and Ollmann speak to the literary and visual importance of Canadian indie comics. The staff of the Art Gallery of Hamilton collaborated as well, and we extend our gratitude to Tobi Bruce, Melissa Neil, Greg Dawe, Paula Esteves Mauro, Christine Braun and Tara Ng, who have worked tirelessly to present a broad span of Canadian artists bound together by a distinctive literary and visual form. We also remain deeply grateful to the Canada Council for the Arts, the Ontario Arts Council and the City of Hamilton for so generously recognizing and supporting Canadian indie comic artists. 🗨

Shelley Falconer
President & CEO
Art Gallery of Hamilton

A MAKESHIFT TRADITION:
CANADA'S CARTOONING HERITAGE

JEET HEER

IN 1958, Canadian cartoonist Doug Wright attended a lavish international cartoonist summit in Amsterdam sponsored by KLM Airlines where he got to meet one of his heroes, Zack Mosley, creator of the popular comic strip *The Adventures of Smilin' Jack*, and ask him for some advice on how to crack the American market.

Born in England in 1917, Wright had immigrated to Canada in 1938 and, after a long apprenticeship as a commercial artist, had made a name as arguably the most famous and successful postwar Canadian cartoonist. He was best known for his weekly strip *Nipper*, tracking the wordless misadventures of a rampaging rapscallion whose gleeful anarchy kept his parents on edge. Appearing in *Weekend*, a supplement that was included in a handful of Canadian newspapers, *Nipper* delighted a million and a half Canadian homes once every seven days. But doing one strip a week for one publication, however popular, was not enough to sustain a livelihood. Wright took over *Juniper Junction* (a weekly strip for the *Family Herald*) when Jimmy Frise died in 1948, produced editori-

al cartoons for the *Montreal Standard*, and churned out commercial illustrations for magazines.

Diligent and hard-working, beloved by editors as a consummate pro, Wright carved out a patchwork career for himself as a cartoonist in Canada, but he had long dreamed of making it big in America, where top syndicated cartoonists were wealthy celebrities. This was not an idle fantasy but a simple financial reality: the most successful Canadian-born cartoonists of that era were those who left for the United States, be they Palmer Cox (creator of the marketing phenomenon *The Brownies*), Richard Taylor (a fixture in the *New Yorker*) or Hal Foster (celebrated chronicler of *Prince Valiant*). If Wright could follow their path, he wouldn't have to keep juggling assignments and could focus his talents on one strip.

In 1945, Wright corresponded with the American cartoonist Ham Fisher, creator of the guileless lunkhead boxer Joe Palooka, in the hopes of getting tips for making it in the big time. In a disappointing trip to Manhattan in 1946, Wright found he didn't have

the right gag-making sensibility to impress the editors of the *New Yorker* and the *Saturday Evening Post*.

Meeting Mosley in Amsterdam rekindled Wright's curiosity about working in the States. Wright had long admired Mosley. Mosley's *Smilin' Jack*, a ramshackle burlesque of aviation adventures that appeared in more than three hundred newspapers, was one of the inspirations for *Clewless McGoon*, a comic strip Wright created for military newspapers while serving in the Royal Canadian Air Force during the Second World War.

Mosley told Wright that the American cartooning scene was too competitive and, for every success story, "there are thousands who took to drink, couldn't stand the pace, or otherwise didn't measure up." If Wright was making "a half-decent living" in Canada, Mosley suggested he "should stay there."

Wright was reluctant to give up the dream of American success and would a few years later query another successful cartoonist, Hank Ketcham, creator of *Dennis*

the Menace. Still, Wright ended up following Mosley's advice and sticking to the jerry-rigged niche he had created for himself in Canada.

Wright is an emblematic figure for Canadian comics, an influence on many of the artists working today not just for the high quality of *Nipper* and other strips but also a paradigm because his makeshift career shows the peculiar survival skills that are necessary for anyone who wants to cartoon in Canada. Unlike the United States, or France, or Japan, Canada has never had a thriving comics industry that allowed artists to specialize. There have been newspaper jobs, magazine assignments, and more recently, graphic novels (usually drawn in time squeezed between other, more lucrative work).

Very few of the major cartoonists gathered in this exhibit have had the luxury of a full career devoted to nothing but cartooning. This can be seen in the four contemporary cartoonists singled out for prominence: Seth (pen name of Gregory Gallant) born in Clinton, Ontario, in 1962; Chester Brown (born in 1960), Fiona Smyth (1964), and Julie Doucet (1965) all hail from Montreal—a city that by that fact alone deserves the title of Queen City of Canadian Cartooning.

Seth's cartooning work has been supplemented by commercial illustration, book design and fine art. Julie Doucet is a central figure in the history of comics, yet they form only a decade in her broader career as an artist. Fiona Smyth has also balanced

cartooning with other pursuits—as a muralist, painter, children's book illustrator and animator, among other practices. Chester Brown is the exception: a Canadian cartoonist who has been single-mindedly focused

Fig 1. Detail, *Nipper and the Cat and Mouse*, 1973, pen and black ink on commercial board with acetate overlay, 26.2 x 38.5 cm, Courtesy of Library and Archives Canada e011297331.
© Estate of Doug Wright

on drawing comics. That Canadian cartoonists have so often had to branch out into other fields has, in truth, been a blessing in disguise, a source of enrichment from a range of artistic forms. Perhaps the best example is how Fiona Smyth's murals (with their noodly outlines and placement of characters in allegorical, as opposed to three-dimensional, space) cross-pollinate with her cartooning.

Emerging in a sparsely populated country, overshadowed by larger cultures, cartooning in Canada has always been a matter of survival on the margins. Cartooning itself has, at the best of times, been a marginal art form, existing at the perilous intersection between fine art, narrative and mass culture. Canadian cartoonists are thus doubly marginalized.

The condition of marginalization, of working in a perilous cultural environment where survival is never assured, has given Canadian cartooning its deepest connections with the nation's artistic and literary traditions. *Survival*, as Margaret Atwood titled her 1972 "thematic guide to Canadian literature," is a venerable Canadian preoccupation.

Expanding on Atwood, the literary critic David Ketterer, in his 1992 book *Canadian Science Fiction and Fantasy*, argued, "America's aggressive attitude toward nature and the unknown, whatever lay west of the ever-advancing frontier, translates readily into the mythology of conquering and domesticating the unknown that finds expression in much [science fiction]. The Canadian attitude seems to be that nature is simply too vast, too threatening, too powerful: man is nature's victim rather than the reverse. Survival, not conquest, is the issue. The best that can be hoped for is some kind of accommodation."

Cartoonists, of course, work not in abstract themes but in images. Writing about Doug Wright and the other major cartoonists of the twentieth century such as James Simpkins (1910–2004), Seth located their importance in the way they modernized the inherited iconology of survival.

EMERGING IN A SPARSELY POPULATED COUNTRY, OVERSHADOWED BY LARGER CULTURES, CARTOONING IN CANADA HAS ALWAYS BEEN A MATTER OF SURVIVAL ON THE MARGINS.

"It's an almost entirely neglected fact that these artists, who worked mostly in the middle of the twentieth century, had an instrumental role in taking the mouldy old nineteenth-century images of Canada and making them modern," Seth contended in the book on Doug Wright that he designed and co-edited with Brad Mackay (*The Collected Doug Wright: Canada's Master Cartoonist*, 2009). "They recast those Mounties and trappers and habitants into contemporary (for that era) streamlined icons. It's the kind of thing, done in plain sight, that no one thinks to notice. The Canadian pop culture images that we know so well today were largely reshaped in those times. Images which had once served a wilderness culture were recontextualized with humour and machine-age drawing styles for a Canada that was turning largely urban and suburban. We can almost chart Canada's transformation from the rural to the urban in a time flow chart from Jimmie [*sic*] Frise to Doug Wright to Peter Whalley."

By this account, Wright, Simpkins and the other pioneers created a vernacular Canadian iconology, one that was pervasive in newspapers and magazines during the golden age of print. Hence, the imprint of "wilderness culture" persisted even as Canada became a predominately urban and suburban nation.

Beyond the thematic concern with survival, the inheritance of wilderness culture explains the special type of individualism that so often marks Canadian graphic narrative: not the conquering individual on the frontier or the triumphant rags-to-riches hero, but the contemplative, quirky, self-exploring, solitude-seeking individual. Even in the work of Doug Wright, who operated in a commercial context, there is a striking eschewal of cuteness and chumminess, the usual softening gestures by which cartoonists make misbehaving characters palatable. Wright's attitude toward his char-

WRIGHT, SIMPKINS AND THE OTHER PIONEERS CREATED A VERNACULAR CANADIAN ICONOLOGY, ONE THAT WAS PERVASIVE IN NEWSPAPERS AND MAGAZINES DURING THE GOLDEN AGE OF PRINT.

acters seems to be, "Here's who they are, take them or leave them as you will." This diffidence might seem chilly but opens up the possibility of a liberating candour. As Canadian cartooning moved away from the commercial realm into the less constrained realm of alternative comics, this clear-eyed honesty has remained a frequently used technique, especially in the work of Chester Brown.

This obdurate individualism, with its respect for oddballs and misfits, opened a plethora of narratives exploring sexual diversity and the fluidity of gender identity (especially notable in the works of Brown, Smyth and Doucet, but also evident in many up-and-coming cartoonists).

Canadian cartoonists are a diverse lot, working in many styles and genres, taking inspiration from a myriad of traditions, so it's a mug's game to try to pigeonhole them into one slot. Still, despite the variety of talents on display, if we examine their careers, certain patterns become apparent.

Since the 1970s, the most potent talents in the field have been working in alternative comics, rooted in small-press publishing and countercultural values, rather than the older tradition of commercial work that prioritized mass appeal. Chester Brown has been a pathbreaker in the turn toward alternative comics. Although his first published cartoon, done when he was eleven, was an homage to Doug Wright, Brown's mature work was shaped by the underground comics of the 1960s and 1970s, with their frank explora-

tion of sex and altered psychological state. His initially self-published series *Yummy Fur*, which started in 1983, was infused with absurdist humour, with a strong bent toward the scatological, as with the tale of the man who couldn't stop defecating.

In 1986, *Yummy Fur* was picked up by Vortex Comics, and in 1991 Brown moved to Drawn & Quarterly, which became the cornerstone of Canadian alternative comics. (Many other artists in this exhibit, including Seth and Doucet, have published the majority of their comics with Drawn & Quarterly.) A restless experimenter, Brown moved on from the Dada hijinks of his early *Ed the Happy Clown* (1989, subsequently revised) to do non-fiction work that is superficially more down-to-earth but marked by a masterful ability to register a striking variety, from the tender melancholy of *I Never Liked You* (1994), to the fusion of memoir and polemic of *Paying for It* (1994), to the historical biography of *Louis Riel* (2004), to the revisionist biblical exegesis of *Mary Wept Over the Feet of Jesus* (2016).

Brown and Seth have occasionally featured each other as characters in their autobiographical comics and the two artists, friends since the 1980s, serve as useful foils for each other. The taciturn Brown contrasts with the chatterbox Seth, a division echoed in the comics themselves, with Brown's focus on external action (taking a cue from classic comic strips like *Little Orphan Annie*) and using long shots as a distancing device finding its antithesis in Seth's use of comics to explore the internal life of his characters via monologues,

soliloquies and extended bouts of rumination, sometimes interspersed with excursions into dreams.

Often wrongly pegged as a dandy and nostalgist, Seth is in fact a Borgesian counterfeiter, setting up camp in the uncertain zone between fact and fiction, where he can invent pasts that didn't quite exist but perhaps should have. He's given us the fictional town of Dominion, and an array of imaginary Canadian car-

Plotte from 1991 to 1998. As a Francophone coming of age in Montreal, she grew up with the classics of Franco-Belgian comics (Tintin, Asterix and company) and as an adult took inspiration from the American tradition of underground comics as created by figures like Robert Crumb, Carol Tyler, and Krystine Kryttre. Like the best underground cartoonists, Doucet was unhampered by any inhibitions. *Dirty Plotte* was a revolutionary exploration of

all merged together to create a syncretic psychedelic vision.

As with Doucet, Smyth has found comics to be an ideal vehicle for disrupting traditional and patriarchal ideas of proper feminine behaviour. "My childhood was full of contradictory messages of feminine compliance and the burgeoning women's movement," Smyth told the *Dalhousie Review* in 2018. "When I got my period I was attending a private Catholic girls' school where no one spoke of periods and students in grades 7, 8, and 9 weren't even allowed to carry purses. The female self-image was all about outer appearances, menstrual secrecy, and being of service to others. Thankfully my family moved to Toronto, and I was enrolled in an arts high school where girls proudly spoke about being on the rag!"

DOUCET WAS UNHAMPERED BY ANY INHIBITIONS. DIRTY PLOTTE WAS A REVOLUTIONARY EXPLORATION OF DOUCET'S PSYCHE, WITH A FOCUS ON BODY ISSUES: THE INTERPLAY OF DESIRES AND ANXIETIES, FANTASIES AND BIOLOGICAL IMPERATIVES.

toonists who, in another dimension, might have rubbed shoulders with James Simpkins and Doug Wright. To complicate matters, he's also done research into actual Canadian cultural history. The goal of this busy work, which often extends outside the page to assembling a cardboard city and other tangible simulacrums, is to create an imaginatively inhabitable world: not to wallow in the past as those intoxicated by nostalgia do but rather to manufacture artifacts that bridge the gap between what happened in the past and what we might have wanted to happen. As a result the past ceases to be fixed, settled and unchangeable and becomes instead a place we can journey into or even a personality we are in dialogue with.

Julie Doucet, like Brown, started as a self-publisher of zines before finding a home at Drawn & Quarterly, which published her series *Dirty*

Doucet's psyche, with a focus on body issues: the interplay of desires and anxieties, fantasies and biological imperatives.

In the pages of *Dirty Plotte*, there seemed nothing Doucet was afraid of drawing: dreams of having a penis, a menstrual flow that becomes a biblical flood sweeping through the city, sex with bottles. With a dense, drippy, viscerally grotty style, Doucet created some of the most daring comics in history.

Fiona Smyth, who grew up in Montreal before moving to Toronto with her family when she was fourteen, also emerged out of the nexus of underground comics and zine-making. Raised a Catholic, her work is characterized by a strong fascination with iconic forms borrowed not just from Christianity but many other faith traditions such as Native animism, Hinduism and Buddhism,

Speaking about her 1987 comic *Whore/House* Smyth noted, "The purpose was to critique the stereotypical roles forced on women by society, such as virgin/whore or mother/slut, which reflect a kind of naive 1950s view. I wanted to portray how women aren't singular characteristics; rather, we are good/bad and ugly/beautiful all at the same time. In other words, I was embracing all of these roles simultaneously in a super-energized graphic way."

Artists like Brown, Seth, Doucet and Smyth represent only a small sampling of the exciting work now being done in Canadian comics, a growing literature that through its thematic boldness and visual elan has won a robust and expanding audience both in Canada and internationally. Canadian cartoonists have always had trouble surviving in a national culture rarely conducive to their art. Yet against the odds our cartoonists have forged a homemade tradition, a makeshift legacy that will last. 🐟

WELCOME! TO THIS IS SERIOUS: CANADIAN INDIE COMICS AT THE ART GALLERY OF HAMILTON!

I'M JOE OLLMANN, POSSIBLY THE CITY OF HAMILTON'S 5TH OR 6TH MOST BELOVED CARTOONIST, AND I WAS CO-CURATOR OF THIS SHOW...

THIS IS SERIOUS AGH

ALONG WITH ALANA TRAFICANTE HERE...

HEY ALANA, WHATCHA DOING?

KLIK KLIK KLAK

I'M WRITING A CURATORIAL ESSAY, JOE. IT'S COMING UP IN A FEW PAGES IN THIS SAME PUBLICATION!!!

HAHA! WELL, GET TO IT!!

SMALLS

COME ON, LET'S GO INSIDE AND SEE THE SHOW...

THIS IS SERIOUS AGH

BUT BEFORE WE DO, I JUST WANT TO SAY THAT GRAPHIC NOVELS, OR COMIC BOOKS, OR COMICS — WHATEVER YOU CALL THEM — DON'T NEED THE APPROBATION OF A FANCY ART GALLERY SHOW LIKE THIS ONE...

COMICS ARE A NOBLE ART FORM WITH A LONG PEDIGREE... A GRAPHIC NOVEL WON THE PULITZER PRIZE...

"MAUS" ART SPIEGELMAN 1992

...ANOTHER GRAPHIC NOVEL RECENTLY MADE THE MAN BOOKER PRIZE LONGLIST. CARTOONISTS HAVE BEEN AWARDED MACARTHUR "GENIUS" GRANTS.

THE THOUSANDS OF MAINSTREAM MEDIA REPORTS THAT "POW! ZAP! COMICS AREN'T JUST FOR KIDS ANYMORE" MAKE IT CLEAR THAT COMICS ARE ACCEPTED AS A LEGITIMATE ART FORM AND ARE REAL LITERATURE.

BIF! ZAP! COMICS CAN BE READ BY SANE ADULTS NOW

SO, WE DON'T NEED TO BEAT THAT DEAD HORSE ANYMORE!!

YET YOU JUST SPENT LIKE, HALF A PAGE ON IT... MY ESSAY'S DONE!!

HERE'S THE THING, I'VE BEEN TRYING FOR YEARS TO GET A GALLERY TO PUT ON A FANCY COMICS SHOW LIKE THIS.

COMICS MIGHT NOT NEED THIS SHOW, BUT MAYBE THE GENERAL PUBLIC NEEDS THIS SHOW...

WOW, THAT'S MAYBE OVERSELLING IT A BIT, JOE...

TOBI BRUCE, AGH HEAD CURATOR

FIRST THING, LET'S TALK ABOUT THE TITLE. *THIS IS SERIOUS* IS A TITLE MEANT TO CONFOUND SLIGHTLY. **IS** THIS SERIOUS? WELL, PARTLY...

THIS IS SERIOUS

WE MEAN TO SUGGEST THAT THE FORM OF INDIE COMICS DESERVES TO BE TAKEN SERIOUSLY. BUT THE COMICS IN THIS EXHIBIT ARE NOT ALL SOBER CAPITAL "A" ART.

AS WITH ANY ARTISTIC ENDEAVOUR FOR GROWN PEOPLE— AS IN LIFE—THE MOST SERIOUS EVENTS ARE BALANCED WITH HUMOUR, AND THERE IS A LOT OF FUNNY WORK IN HERE.

I'M NOT A DETECTIVE, IT'S A CASE OF DIARRHEA!!

HA HA

THERE ARE PURE FUNNY DRAWINGS AND CLASSIC SLAPSTICK AS WELL AS DEFT COMIC WRITING. THERE MAY EVEN BE FART JOKES.

MORE COMICS

PEFF

BUT THERE ARE ALSO MEDITATIONS ON POLITICS, FEMINISM, SEXUALITY, LIFE AND DEATH.

INDIE COMICS FEATURE MANY OF THE SAME CHARACTERISTICS AS INDIE FILM: SMALLER, MORE PERSONAL STORIES. NOT BIG-MONEY BLOCKBUSTERS, BUT INTIMATE, AUTEUR PRODUCTIONS.

MOST OF THE PAGES YOU'LL SEE WERE CREATED, WRITTEN AND DRAWN BY A SINGLE PERSON.

WORKING ALONE FOR HUNDREDS OF HOURS.

IT'S A LONELY PROFESSION.

IT IS.

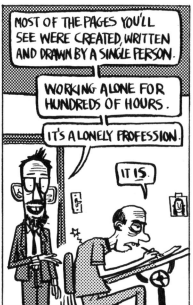

THAT'S WHAT I'M EXCITED FOR PEOPLE TO SEE; A BIT OF THE BEHIND THE SCENES, THE HUMAN HAND THAT CREATES ALL THIS WORK.

WAIT... COME BACK!

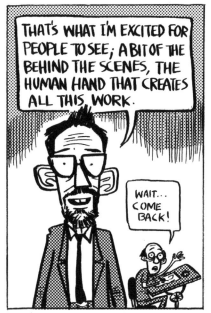

WE'VE TRIED TO SHOW THE WIDE RANGE OF APPROACHES, FROM THE TRADITIONAL METHODOLOGY OF PEN AND INK TO COLLAGE, WOOD AND PAPER CUTS AND THE GROWING USE OF DIGITAL TOOLS IN COMICS.

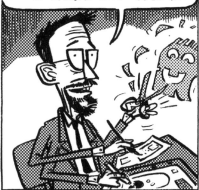

WHICH WE FOUND WAS WIDESPREAD, AND LEAVES NO "ORIGINAL ART" TO DISPLAY IN A GALLERY SHOW. WHICH PRESENTED CHALLENGES TO SAY THE LEAST.

WHAT? YOU DON'T HAVE ANY ORIGINAL ART?

SORRY, GRAMPS...

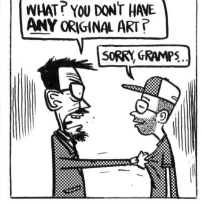

OTHER CONSIDERATIONS WERE TO SHOW PAGES THAT ARE VISUALLY APPEALING BUT ALSO CONTAIN A SNIPPET OF NARRATIVE THAT CAN BE READ— PAGES THAT GIVE A SENSE OF THE CARTOONISTS' STYLES.

MY HOPE IS PEOPLE WILL SEE EXCERPTS HERE AND SEEK OUT OTHER WORK BY THESE CREATORS.

YES, I'M HOPING THIS SHOW IS A GATEWAY DRUG TO THE UNINITIATED IN COMICS...

THIS IS YOUR BRAIN ON COMICS...

THE PREPARATORY CREW AT THE AGH HAD GREAT SOLUTIONS TO THE UNIQUE CHALLENGES OF HOW TO PRESENT COMICS IN A GALLERY SETTING...

THOUGH THEY NIXED MY GREAT IDEA OF USING RADIATION GLOVES TO HANDLE THE CARTOONISTS' SKETCHBOOKS!

(THIS IDEA IS STILL AVAILABLE FOR FUTURE GALLERY SHOWS. OTHER CURATORS, D.M. ME!)

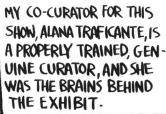

MY CO-CURATOR FOR THIS SHOW, ALANA TRAFICANTE, IS A PROPERLY TRAINED, GENUINE CURATOR, AND SHE WAS THE BRAINS BEHIND THE EXHIBIT.

GUESS THAT MAKES ME THE "BRAWN," HEY!

I WAS BROUGHT IN AS AN AMATEUR, "THE INSIDER," AS I KNOW MOST OF THE CARTOONISTS... I'M KIND OF THE RANDY BACHMAN OF CANADIAN COMICS...

SOMETIMES I JOKED MAYBE THEY JUST PICKED ME BECAUSE I HAD ALL THE CARTOONISTS' EMAIL ADDRESSES! HA HA!

HEH HEH

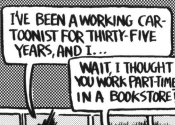

I'VE BEEN A WORKING CARTOONIST FOR THIRTY-FIVE YEARS, AND I...

WAIT, I THOUGHT YOU WORK PART-TIME IN A BOOKSTORE?

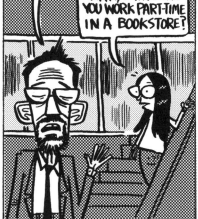

HA HA! YES, I ONLY WORK **PART**-TIME; THAT MEANS I'M A HIGHLY SUCCESSFUL CARTOONIST!

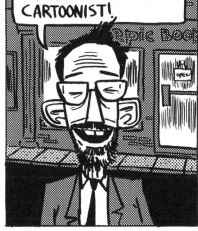

THE MAIN THING WE SET OUT TO HIGHLIGHT IN THIS SHOW IS THE WIDE RANGE OF APPROACHES AND PRACTICES IN CANADIAN COMICS.

WE'RE LUCKY IN CANADA TO HAVE SO MANY INCREDIBLE CARTOONISTS!

AS A CURATOR, MAYBE **TOO** MANY!

IT WAS VERY DIFFICULT TO NARROW DOWN THE LIST TO A MANAGEABLE NUMBER, AND, INEVITABLY, MANY GREAT CARTOONISTS COULDN'T BE INCLUDED IN THE SHOW.

THEY ARE IN... THEY ARE OUT... OH GAWD...

SCRATCHA SCRATCHA!

AND REMEMBER, I'M *THE INSIDER*, WHO KNOWS EVERYONE! THEY'D ALL BE MAD AT **ME**. THEN, I CAME UP WITH THE IDEA THAT IF **I'M** NOT IN THE SHOW, NO ONE CAN BE MAD AT ME!

HA HA! GUYS! **I'M** NOT IN THE SHOW EITHER!!

I'M NOT EVEN IN THE SHOW!

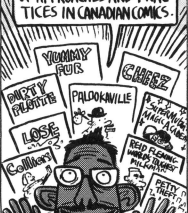

WAS HE EVER GOING TO BE IN THE SHOW?

NO, WE JUST NEEDED HIM FOR THOSE EMAIL CONTACTS.

THIS IS SERIOUS!

END!

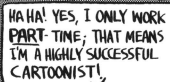

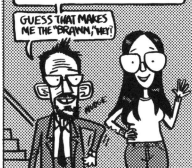

THIS IS SERIOUS:
A CULTURAL THEORY FOR COMICS

ALANA TRAFICANTE

This book documents *THIS IS SERIOUS*, a national survey of Canadian cartoonists working in the expansive genre of indie comics. Presenting the work of forty-seven comic artists in the context of an art museum took an incredible effort. Over the course of one year, my co-curator, Joe Ollmann, and I conducted over thirty studio visits in Hamilton, Toronto, and Montreal. We held countless meetings over eggs and diner coffee, writing and rewriting artist lists. We penned hundreds of threads of email exchange and took a regrettable number of GO bus rides. We also led cross-departmental planning meetings at the Art Gallery of Hamilton, often around their amazing 1970s built-in boardroom table. We did all this on top of our full-time gigs: Joe is a cartoonist (who managed to draw a complete book in the same passage of time), and I am the director of Gallery 44 Centre for Contemporary Photography. To say the very least, producing this exhibition was hard work, but it was a labour of love.

As co-curator of the project and co-editor of this book, I did not set out to validate indie comics by writing the genre into the art historical canon. Nor was it my intent to interrupt the dominant narrative regarding the fineness of fine art, so to speak. The canon is both a taxonomical and marginalizing tool: it ranks, classifies and authenticates, and it serves to exclude more often than it includes. That tradition is not aligned with the spirit of indie comics. Rather than crafting an argument for contemporary comics in a 1:1 ratio with contemporary art, this project instead sets out to discard that lens in the interest of seeing a distinct genre more clearly. Just as curatorial practice can exist adjacent to and divergent from acts of art historicization, comic arts occupy a space independent of their fine arts counterparts.

That space *is* serious. Indie comics present a unique sector of cultural production where text and image meet, where literature and graphic arts come to co-exist, where narratives unfold visually, and lives manifest in panels on the page. Indie comics are not just a subculture—they are a culture in their own right. The comics world comes complete with training programs, residencies, mentorships, publishers, grants, book deals, fairs, awards, and a bevy of emerging, mid-career, and established artists. Yes, lone makers toil away in their quiet hermit-like studios, but there are also collective spaces and collaborative projects like drawing nights and zine clubs. Comic artists conduct in-depth research, self-publish and work across genres and disciplines, in a host of material practices including animation, collage, illustration and writing. And of course, this world has its own gatekeepers, those who make it to the mainstream, and conversely, those who forge an alt-scene and thrive in the underground.

Indie comics, as Joe Ollmann so aptly stated in his introductory comic to this book, share a likeness to indie filmmaking with their inherent capacity to harness personal storytelling in intimate, imaginative and unassuming ways. Indie comics take up important questions concerning the broader contemporary culture. Through a range of narrative forms—fantasy, horror, humour, [auto]biography, myth, and the absurd—comics present a uniquely accessible platform for

myriad critical dialogues concerning race, sexuality, oppression, family, politics, being, and self-knowledge. And, reflecting this variable and vast genre, *THIS IS SERIOUS* presents one perspective on a vibrant, expansive, ever-changing artistic practice.

So, for the task of harnessing all this action into the frame of a curatorial essay, I propose we look to indie comics as a form of cogent critical commentary—that we look through the media to its message—and acknowledge the tireless, under-recognized efforts of these artists as agents of social and cultural change. The care, wit and intimacy infusing each story make them highly effective. What follows is an attempt to align the nuanced, personal storytelling of indie comics with some of the key fields driving cultural discourse today.

FEMINISM

Truth told, feminism is not the first school of thought typically associated with indie comics. The general perception is that the field of comic arts is dominated by white men ranting about their white-male problems. While on the one hand this may be true of the genre (because of what field is it not true), on the other hand, some of the most prolific and influential Canadian cartoonists are women or women-identified. Since the 1980s, comics have served as a potent, grassroots

mode of resistance to the systemic subjugation of women. Just as feminism can be at its most galvanizing when responding to its internal paradoxes and tensions, feminist comics (and their intersection with zine culture) are most potent when lashing out at the supposed white male milieu of comic arts.

Third-wave feminism marked an essential turn toward understanding multiple female subjectivities and the complexities of situated experience. Abandoning previous notions of a singular and unified female world-view, and harnessing the prismatic effect of that spectral approach, many feminist Gen Xers, alongside proponents of the influential 1990s Riot Grrl movement, lauded a message of radical resistance to patriarchy through the language and sonic and visual aesthetics of punk rock. Within punk's associated subculture, Gen X feminist cartoonists employed these aesthetics to crack apart former notions of a subdued female voice.

West Coast artist Carel Moiseiwitsch was at the vanguard of Canadian feminist cartoonists. Her 1985

Fig 2. Julie Doucet, *En manque*, 1987

comic *Fatal Fellatio* is perhaps one of her most unsettling and memorable works. In this searingly visceral and graphic retelling of a woman's last sexual encounter before her death by suicide, the story's central figure commands each page with a decided sense of sexual and existential agency. Montreal's Julie Doucet closely followed in these footsteps, creating cutting and wry stories of resistance with women as their central protagonists. Significant among them is Doucet's seemingly unforgettable *Heavy Flow* (1989), a four-page comic in which a blood-soaked, Godzilla-sized woman takes to the streets on an enraged hunt for a tampon. Often cited by male and female contemporaries as one of her most groundbreaking works, Doucet's story marries a strong sense of female urgency with raunchy punk aesthetics, creating a near-perfect visual rendering of the Riot Grrl feminist sentiment.

Next generation cartoonists are too making significant contributions to the discourse of new intersectional feminisms. Intersectionality contends that feminism is not just a movement of white, cisgender women, and that experiences of oppression

INDIE COMICS PRESENT A UNIQUE SECTOR OF CULTURAL PRODUCTION WHERE TEXT AND IMAGE MEET, WHERE LITERATURE AND GRAPHIC ARTS COME TO CO-EXIST ... INDIE COMICS ARE NOT JUST A SUBCULTURE—THEY ARE A CULTURE IN THEIR OWN RIGHT.

occur to varying degrees, based on their intersection with other social-locative factors (including ability/disability, race, sexuality, class and ethnicity). Pushing beyond the riot-fuelled, punk-inspired stories of the third-wave, post-Gen X and Millennial cartoonists, many of whom identify as queer and/or BIPOC, have contributed a vast range of personal, quiet, humorous, and evocative tales of survivance from female and non-binary subject positions. Jillian Tamaki's work in the field of young adult graphic novels extends a tender and yet incisive approach to the rendering of girlhood in comics. From her collaborative projects with cousin Mariko Tamaki to her solo books, web comics, and anthologies, Tamaki harnesses the complexity of female voice in compassionate, creative and visionary ways.

The use of digital media for comics distribution also exemplifies the burgeoning fourth wave's closeness to internet culture. Aminder Dhaliwal's *Woman World*, for example, first existed as a webcomic before being published by Drawn & Quarterly in 2018. Exploring a tale of a world post-male extinction, Dhaliwal's seri-

JUST AS FEMINISM CAN BE AT ITS MOST GALVANIZING WHEN RESPONDING TO ITS INTERNAL PARADOXES AND TENSIONS, FEMINIST COMICS (AND THEIR INTERSECTION WITH ZINE CULTURE) ARE MOST POTENT WHEN LASHING BACK AT THE SUPPOSED WHITE MALE MILIEU OF COMIC ARTS.

alized comic was drawn on individual Post-its and then released via Instagram biweekly. Similar methods of digital self-publishing now occur across the comics genre, an echo of print-based self-publishing and distribution practices, such as zine culture. Venerated artist Fiona Smyth, for example, continues to publish her weekly comic *Cheez* (originally published as a monthly in *Exclaim!* magazine from 1992 to 2002) via the *Monday Artpost* blog. Smyth is one of Canada's most beloved and enduring feminist cartoonists, whose influence is both interdisciplinary and intergenerational. Her illustrations have influenced visual culture in Toronto since the 1990s (not only in *Exclaim!* magazine and across zine fairs, but also in public spaces including the Sneaky Dee's sign at the corner of College and Bathurst streets), as well as a new generation of cartoonists, many of whom studied under Smyth at OCAD University.

QUEER THEORY

Indie comics also make a meaningful contribution to the growing field of queer theory—both for their potential as texts to be "queered" (read through a queer lens), and their contribution to significant developments in the study and understanding of lived LGBTQ experience. In this field of thought, scholars, artists and critics seek to place the spectrum of sexuality, and its inherent fluidity, as a central concept in our negotiation of culturally located experience. With indie comics, we see the historical repression and marginalization of queer bodies countered by thoughtful, first-person stories. These stories serve to unpack the performativity of gender and attack so-called foundational models of heteronormative sexuality.

Eric Kostiuk Williams's *Hungry Bottom Comics*, a series of loosely sequential narratives created between 2011 and 2012, explore the artist's early years as a young queer man. His imaginative renderings recount a coming-of-age story in all its intensity: coming out to his mother, club nights at Buddies in Bad Times, online dating, IRL dating, relationships, hookups, and STI testing. Finally, he comes to grips with the femininity of his queerness via a wake-up call from his Diva Totem, a character described as "a primordial and sassy-as-fuck entity

Fig 3. Eric Kostiuk Williams, *Condo Heartbreak Disco*, 2016

summoned from the subconscious" in a 2012 issue of *Hungry Bottom Comics*. In the culminating scene, the Diva Totem—a half-body wearing leopard-print leggings and high heels with a coiled braid for torso and head—leads the Hungry Bottom boy to a realization of the hyper-masculinity of his gay scene and the repression of his effeminate sensitivities as such. Visually, the layout of Kostiuk Williams's panels seems to swell with the same crescendo effect as his narrative, culminating when he finds himself in a community of like-minded, self-seeking queer folks.

Kostiuk Williams follows the tradition of artists such as Maurice Vellekoop, who writes stories of queer experience through unique, warm and highly colourful drawings. Vellekoop's "Two Excursions," from his upcoming graphic memoir *I'm So Glad We Had This Time Together*, recounts memories of two trips he took into the city as a child, one with his mother and one with his father. Both are suffused with formative childhood memories of witnessing fashion and film in a palette reminiscent of the Disney animations that inform his visual style. Trans artist Katherine Collins's doll-like character in her *Neil the Horse* comics from the1980s (published under the name Arn Saba) enacts the same theatrical aesthetics of camp. But perhaps most riveting in its retelling of the experience of one trans, queer and racialized person is the collaborative book *Death Threat*, created by Vivek Shraya and Ness Lee (2019). Based on Shraya's real-life experience of multiple death threats, this project uses humour and visual adaptation as modes of dismantling hate, reclaiming an otherwise harrowing narrative.

LABOUR AND CLASS

Our contemporary social climate is marked by rapidly growing economic disparity, with the potential for devastating effects on personal capacity and quality of life. With their uniquely accessible and highly appealing format, indie comics can serve as a tool to initiate consciousness and organize communities in the interest of social justice. Labour, class and gentrification are three key, interrelated topics of reflection and action currently taken up by Canadian cartoonists, social critics and activists alike.

In recent decades, Canadian cities have been impacted by changes in labour markets and manufacturing, with Hamilton perhaps most hard hit. Cartoonist Simon Orpana illustrates how workers in Hamilton made significant contributions to labour history with the book *Showdown!: Making Modern Unions* (2016), in collaboration with historian Rob Kristofferson. Based on interviews

Fig 4. Sylvia Nickerson, *Creation,* 2019

and other archival materials, their book presents a graphic representation of how workers in Hamilton organized in the 1940s and influenced the formation of postwar labour unions across North America. Read alongside Orpana's recent project documenting the East Hamilton Rent Strike, and in particular his ink sketches at the Above Guideline Rent Increase Hearing (2018), we come to understand the artist's attention to the shifting struggles of working-class people and their enduring social movements and resiliency.

Gentrification is undoubtedly a hot topic, and one worthy of critical consideration. By definition, the term refers to the physical and intangible "improvements" to urban areas and related increases in rent and property values, and the displacement of lower-income communities by wealthier people. It is a wave of change often ushered in by the arrival of artist communities, and one that is difficult to stop. Hamilton-based cartoonist Sylvia Nickerson's debut graphic novel *Creation* (2019) presents the

WITH THEIR UNIQUELY ACCESSIBLE AND HIGHLY APPEALING FORMAT, INDIE COMICS CAN SERVE AS A TOOL TO INITIATE CONSCIOUSNESS AND ORGANIZE COMMUNITIES IN THE INTEREST OF SOCIAL JUSTICE.

outlook of an artist who witnesses rapid gentrification, a woman who is both complicit in and troubled by the changes taking place around her. Nickerson's melancholic narrative is rooted in her experience as a mother and artist who moves into a low-income neighbourhood and takes studio space in the city's downtown core. Here she is met with the difficult lived realities of her neighbours and community members, including addiction, poverty and unemployment, alongside the challenges that motherhood imposes on her career as a working artist. Her rendering of this tension results in a painful interplay between privilege and disadvantage, between the agents of change and those cast aside in the interest of economic development. Nickerson's nuanced,

WHAT WE DO KNOW IS THIS: THE FORMAT OF COMICS IS ONE THAT UNIQUELY COMPELS READERS THROUGH AFFECTIVE LITERARY AND VISUAL EXPERIENCES, AND, WHEN USED TO RECOUNT PERSONAL, NUANCED NARRATIVES, CAN AWAKEN ESSENTIAL, CRITICAL UNDERSTANDING OF OURSELVES AND ONE ANOTHER.

empathetic approach to storytelling makes visible the potential to employ a politics of care in developing communities alongside economies.

Cartoonists also use irony, fantasy and humour to make meaningful commentary on issues of labour, class and gentrification. For example, Eric Kostiuk Williams's *Condo Heartbreak Disco* (2017) counters the rapidity of condo development on Toronto's cityscape with two fantastical heroes. Komio and the Willendorf Braid heed the increasing presence of Starbucks Moms, and fight back against the growing power of the twisted CEO. Walter Scott's *Wendy* comics capture humorous renderings of the contemporary artist-as-labourer through truths told in the title character's trials and tribulations, but also through the implicit privilege embodied by the young woman artist and her bevy of art school graduate friends. These strategies present comical and imaginative counterpoints to straight autobiographical and historical narratives, yet still elicit meaningful awareness and self-reflexivity from audiences and readers.

DECOLONIZATION

The cultural discourse of *post*-colonialism proves problematic in the North American context, insofar as its prefix assumes we are living in a period *after* occupation. Communities actively seeking to decolonize (for example, Black and Indigenous communities) have forged critical languages and texts to confront issues tied to their forced immigration

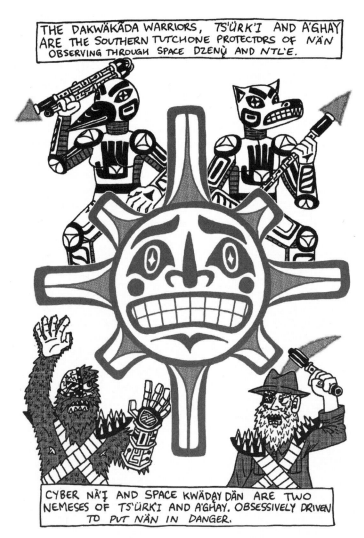

Fig 5. Cole Pauls, *Dakwäkāda Warriors I*, 2016

and subjugation, and the continued occupation of stolen Indigenous land. This multidisciplinary movement rooted in anti-oppressive frameworks affects change in areas of social well-being, the environment, health, justice and housing, and is increasing in prominence across the arts sector as well. Now, more than ever, cultural institutions create space to support such narratives of resistance; however, artists have been producing this critical work for decades and across many different material practices.

Ho Che Anderson is a Canadian cartoonist based in Toronto whose innovative graphic biography *King* was originally released in three volumes between 1993 and 2002. What began as a comic series and grew into an intimate and fulsome biographical portrait of civil rights activist Martin Luther King Jr., *King* is now published as a single, special edition graphic novel (2010). The book is lauded for its ability to reinvent the typical MLK narrative, mixing his public persona with implicit human frailty. The deconstruction of singular narratives, and unpacking the intricate lived experiences of BIPOC individuals (both known and unknown) is a key strategy in coming to know the personal amidst the political. Anderson's humanization of MLK removes an aspect of the state-imposed apparatus through which young Black readers may have previously accessed knowledge of his history. Instead, Anderson presents a new lens through which the reflection-of-self in this leader is perhaps more attainable.

Similarly, Gord Hill's *The 500 Years of Resistance Comic Book* (2010) offers a much-needed antidote to dominant narratives in North American history. Hill's *Comic Book* recounts, with historical accuracy, instances of Indigenous resistance to European colonization from 1492 to 2006. Notably, Hill attributes decolonial

opposition as an active Indigenous practice through the retelling of recent histories such as the 1990 Oka Crisis and the 2006 Grand River land dispute (also known as the Caledonia land dispute). His propensity toward galvanizing anti-oppression carries into Hill's *The Antifa Comic Book* (2018), which explores one hundred years of fascism and related anti-fascist movements. Hill reminds readers that every act of oppression can be met with a subsequent reaction and that resistance is never futile, particularly when it comes to the repatriation of unceded treaty lands.

Emerging Tahltan cartoonist Cole Pauls takes action through strategies of Indigenous Futurism and language revival. *Dakwäkãda Warriors* is a three-part story, written as a sequel to the Pacific Northwest Coast legend "Raven Steals the Sun." In Pauls's imagining, two Indigenous Power Rangers, Wolf and Raven, fight against an evil pioneer. The book was written for Yukon Indigenous children, with the clear intention of creating an opportunity to see themselves represented in comics. In the conclusion to Book 1 (2016), Pauls describes this intention as follows: "I wanted to create this book so Indigenous children could have a hero they could relate to because they were Southern Tutchone, because they were members of the Wolf or Raven Clan, because they are from the Yukon or it's because they are Native Power Rangers flying through space."

Pauls worked with two language-preservers from his community and includes with each book a language key with corresponding page references. His act of preserving and disseminating language through the accessible format of comics underscores the medium's unique ability to reach and inform young readers with ease, and incite meaningful social change through active self-representation.

CONCLUSION

An astounding number of comic artists are working across Canada, with concentrated pockets of activity in Toronto, Montreal and Hamilton, and this exhibition includes the work of only forty-seven of them. Initially, we set out to select material for *THIS IS SERIOUS* based on its ability, in aggregate, to show the broad range of practices under the umbrella of indie comics. In conducting our research, however, themes began to emerge. We realized a shared interest in personal storytelling, and its ability to unpack multiple subjectivities of both the artists and their subjects. We began to actively prioritize the research of women, LGBTQ, Indigenous and POC artists, and in doing so, uncovered a thread of critical commentary occurring across the genre, in a host of timely topics and concerns. Aside from those discussed here, Canadian artists make comics concerning topics of diaspora, technology, aging, sex work, mental health, parenthood and the environment. They write stories about corporate culture, space travel, mid-life crises, friendship, grief and love. We cannot distill the breadth of their intimate storytelling into a single statement on cartoonists' contribution to contemporary culture. What we do know is this: the format of comics is one that uniquely compels readers through affective literary and visual experiences, and, when used to recount personal, nuanced narratives, can awaken essential, critical understanding of ourselves and one another. In their space between literature and visual arts, indie comics offer a magically complex and prismatic worldview. And that is pretty serious. ❦

THE WORKS

SAMI ALWANI

HO CHE ANDERSON

KATE BEATON

MARC BELL

BLAINE

SIMON BOSSÉ

DAVID BOSWELL

CHESTER BROWN

NINA BUNJEVAC

JESSICA CAMPBELL

GENEVIÈVE CASTRÉE

MARTA CHUDOLINSKA

DAVID COLLIER

KATHERINE COLLINS

MICHAEL DEFORGE

JULIE DELPORTE

AMINDER DHALIWAL

JULIE DOUCET

PASCAL GIRARD

GORD HILL

JESSE JACOBS

PATRICK KYLE

GINETTE LAPALME

NESS LEE

HARTLEY LIN

GRAEME MACKAY

BILLY MAVREAS

CAREL MOISEIWITSCH

SYLVIA NICKERSON

DIANE OBOMSAWIN

SIMON ORPANA

MEREDITH W. PARK

COLE PAULS

GORD PULLAR

MICHEL RABAGLIATI

R.A. ROSEN

WALTER SCOTT

SETH

JAMES SIMPKINS

FIONA SMYTH

JILLIAN TAMAKI

MAURICE VELLEKOOP

KAT VERHOEVEN

ERIC KOSTIUK WILLIAMS

CONNOR WILLUMSEN

JENN WOODALL

DOUG WRIGHT

Illustrations in this catalogue are related to the works in the exhibition. Please see List of Works for complete works and details.
All images courtesy the artist unless otherwise noted.

SAMI ALWANI

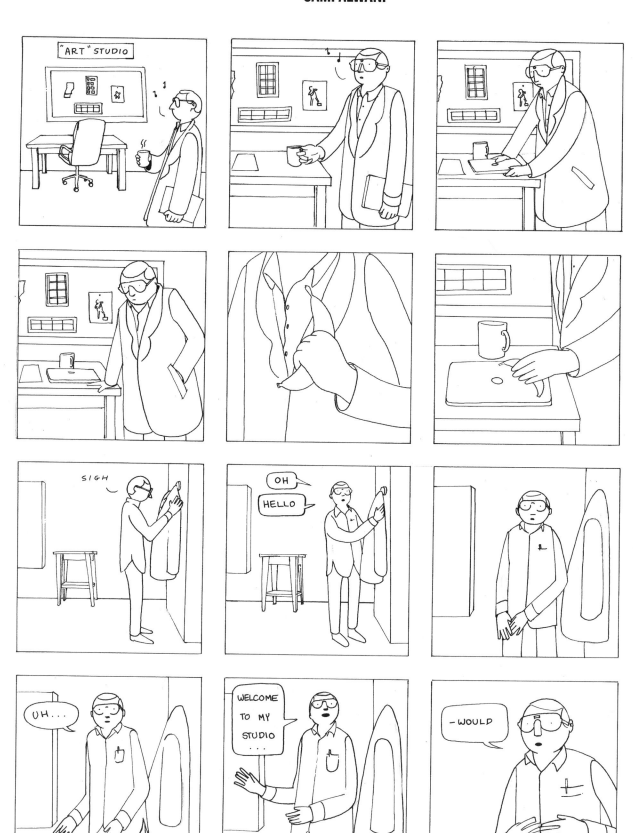

Sami Alwani
The Idiot, 2017

SAMI ALWANI

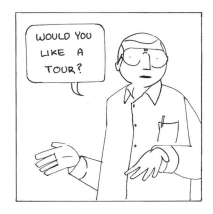
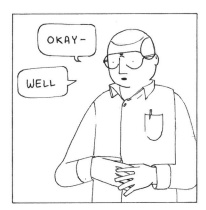

Sami Alwani
The Idiot, 2017

HO CHE ANDERSON

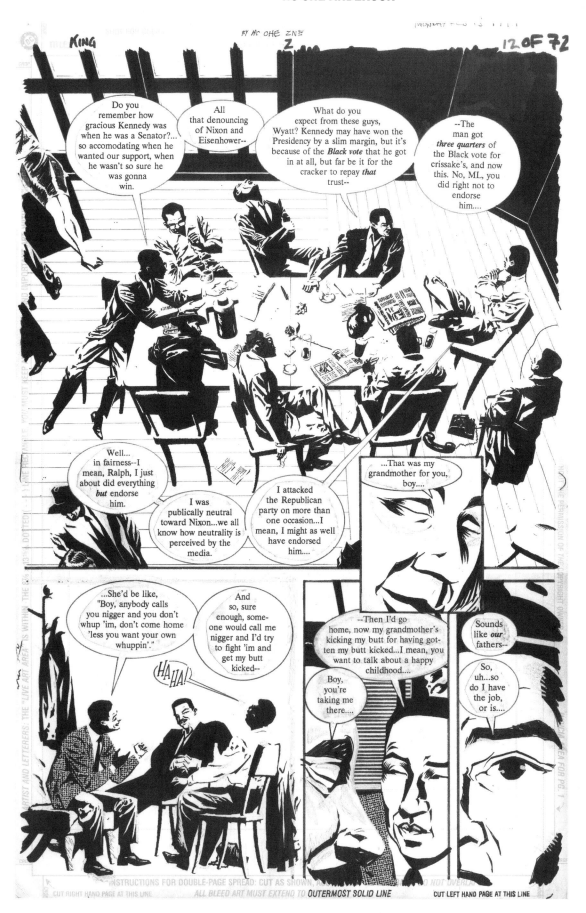

Ho Che Anderson

King: A Comics Biography, 1992

HO CHE ANDERSON

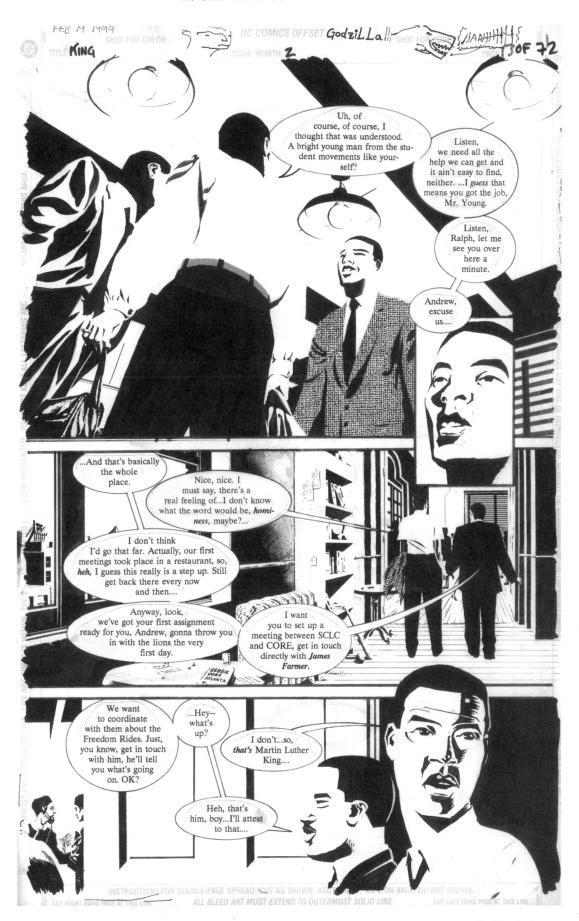

Ho Che Anderson
King: A Comics Biography, 1992

KATE BEATON

JANE EYRE

GOOD TO BE UGLY

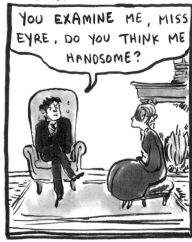

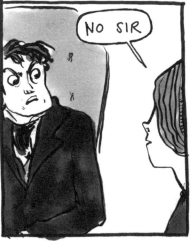

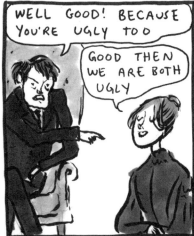

THE SOLUTION

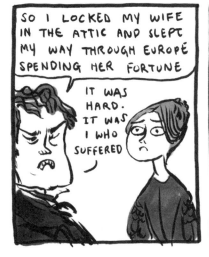

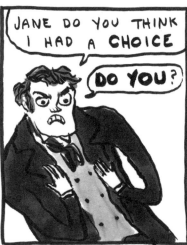

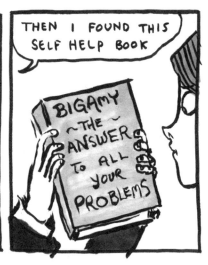

Kate Beaton
Jane Eyre, 2011

KATE BEATON

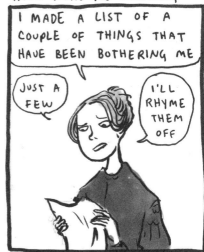

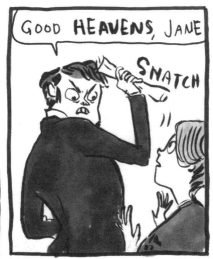

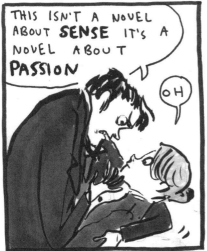

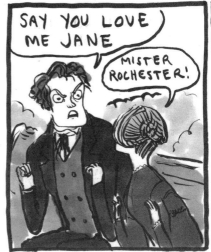

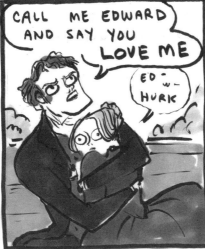

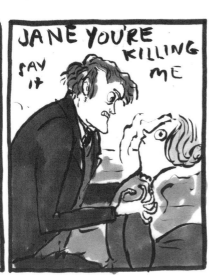

Kate Beaton
Jane Eyre, 2011

MARC BELL

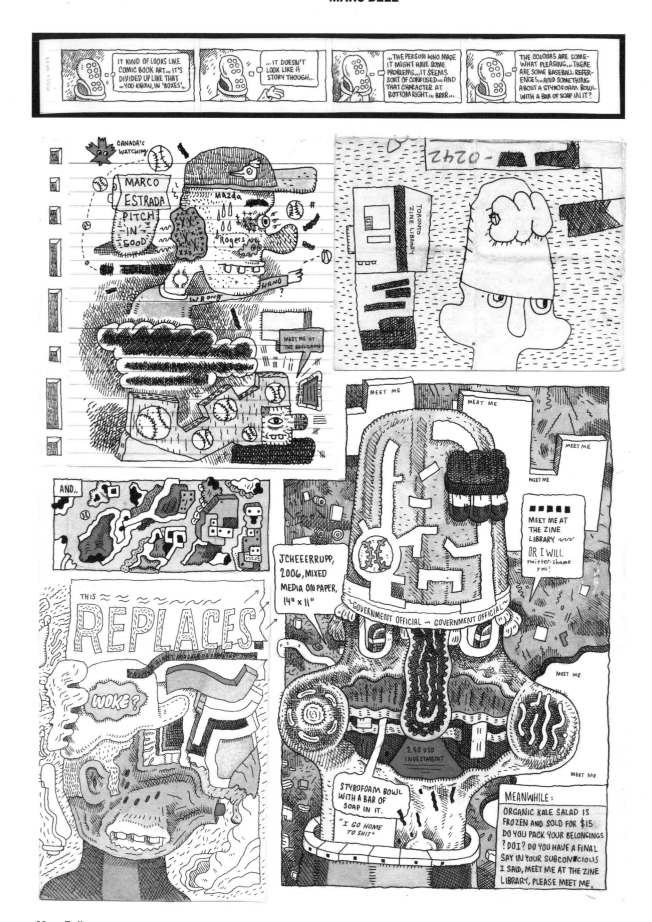

Marc Bell
Upper: *The Ten-Eyed One Visits an Art Gallery*, 2018
Lower: *Marco Estrada Pitch'in Good/Meet Me at the Zine Library or I Will Twitter Shame You (Replaces Jcheeerrupp!)*, 2017

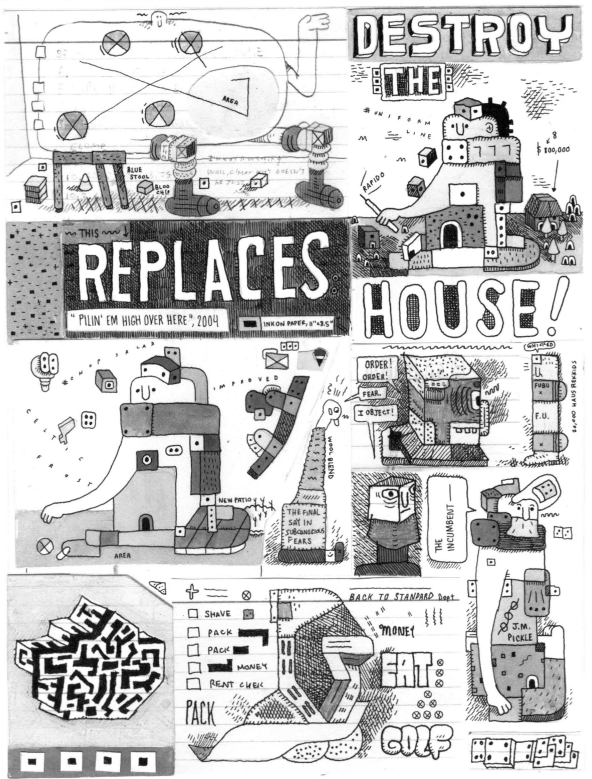

Marc Bell
Upper: *The Ten-Eyed One Visits an Art Gallery*, 2018
Lower: *Destroy The House! (Replaces Pilin' Em High Over Here)*, 2017

Simon Bossé
Intestine, 2002

SIMON BOSSÉ

Simon Bossé
Le Coucou, 2009

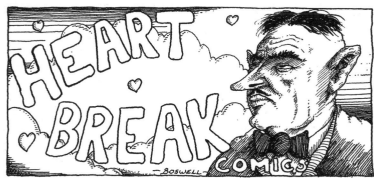
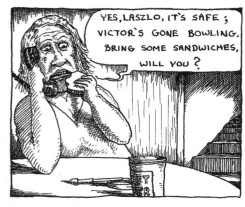
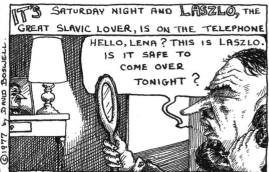

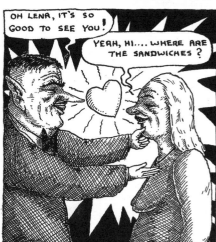

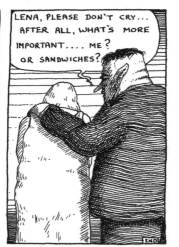

David Boswell
Heart Break Comics #1, 1977

DAVID BOSWELL

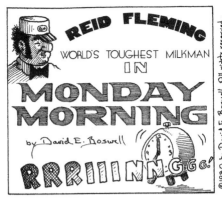

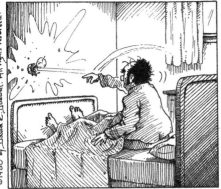

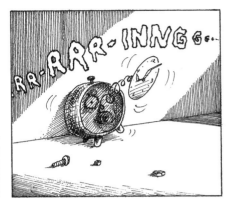

David Boswell
Reid Fleming #1: Monday Morning, 1980

Chester Brown
Paying for It, 2010

CHESTER BROWN

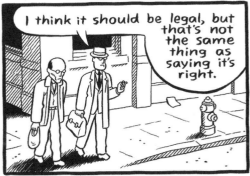

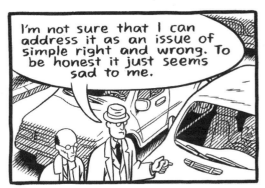

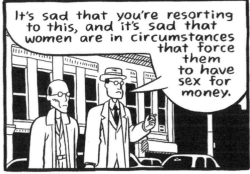

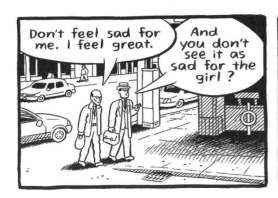

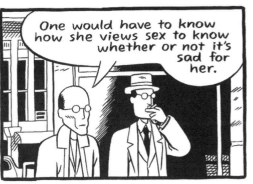

Chester Brown
Paying for It, 2010

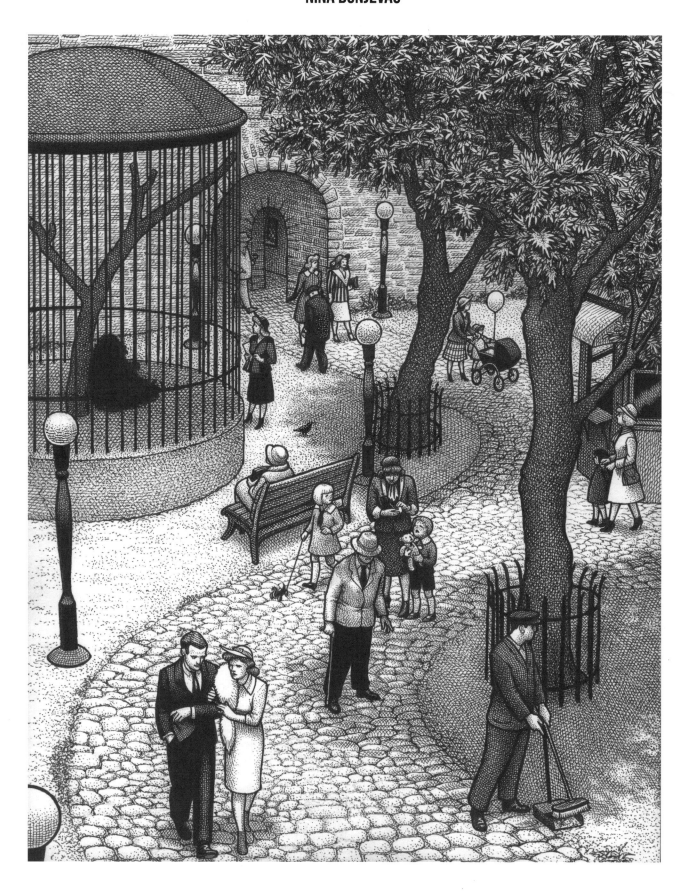

Nina Bunjevac
Bezimena, 2018

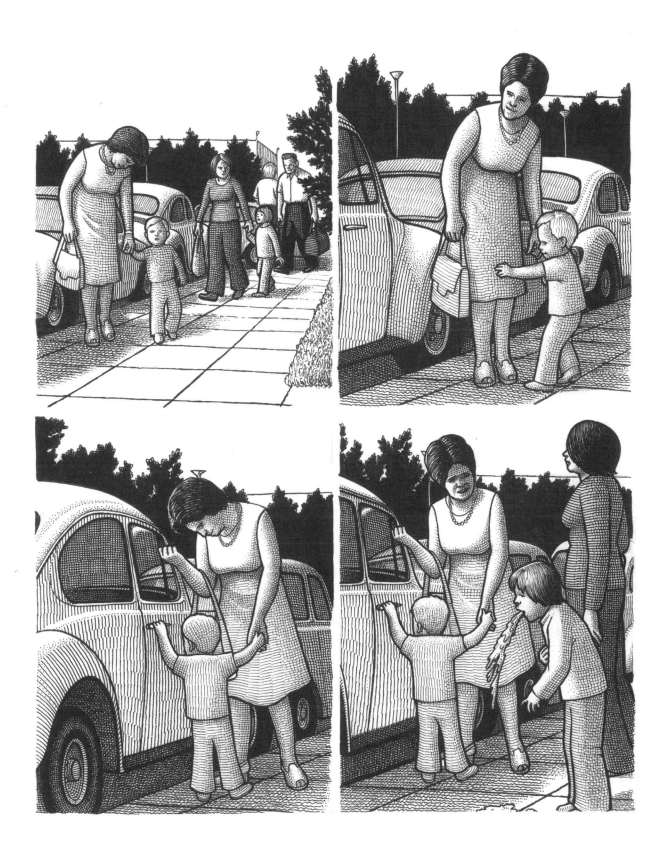

Nina Bunjevac
Fatherland, 2014

Jessica Campbell
XTC69, 2017

Jessica Campbell
XTC69, 2017

GENEVIÈVE CASTRÉE

My mother is the youngest of a family of sixteen children. Her father died when she was still very young. I ask my grandmother to tell me about my great-grandmother, a first nations woman. Most people from Québec have some aboriginal blood, it is not very exotic.

 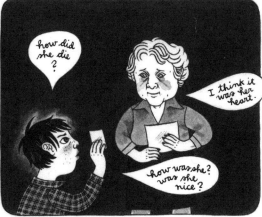

My grandmother lives alone. She is very old, very happy, and very Catholic. Once, I was told that after having her first thirteen children she took a little break for three years until her village priest told her to get on with her "duty as a woman" while she was still good.

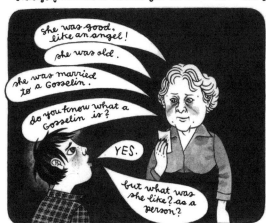 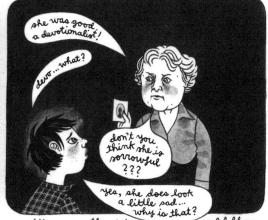

My grandmother forgets our names and confuses us with one another. Who could blame her? I would have trouble writing the list of all my aunts, uncles, girl and boy cousins and their children... Some of them I have never met. As a family, you can know one another poorly.

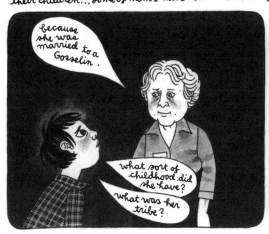 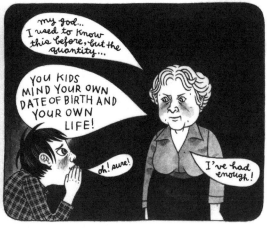

Geneviève Castrée
Susceptible, 2013

GENEVIÈVE CASTRÉE

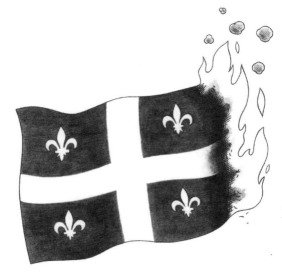

house fire II.

It's St. John the Baptist Day, Québec's national holiday.

At my house it is a big deal, I come from a family of separatists.

Now that anarchy has been explained to me, I see myself as an anarchist.

My friend's house is burning across the street.

Rumours are circulating around the neighbourhood that someone has set fire to the fleurdelisé* that was hanging from the balcony on the second floor. The owners deny it. Someone told me that in cases of arson the insurance company does not pay. Luckily for her, my friend is traveling abroad...

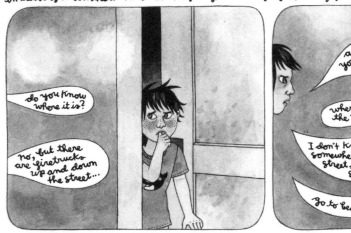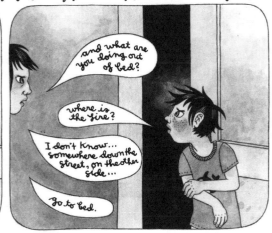

do you know where it is?

no, but there are firetrucks up and down the street...

and what are you doing out of bed?

where is the fire?

I don't know... somewhere down the street, on the other side...

go to bed.

Amer and Amère have bought a house in a suburb on the South Shore where all is quieter. Amer says that more and more immigrants are moving near where we live. It bothers him. Our new house has an above-ground pool and a garden. Everyone tells me how lucky I am.

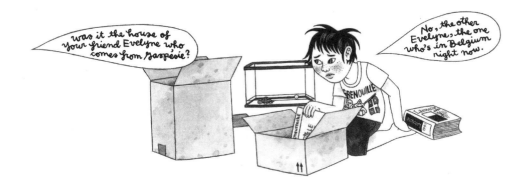

was it the house of your friend Evelyne who comes from Gaspésie?

No, the other Evelyne, the one who's in Belgium right now.

* the name for Québec's flag

Geneviève Castrée
Susceptible, 2013

Marta Chudolinska
Back + Forth, 2008

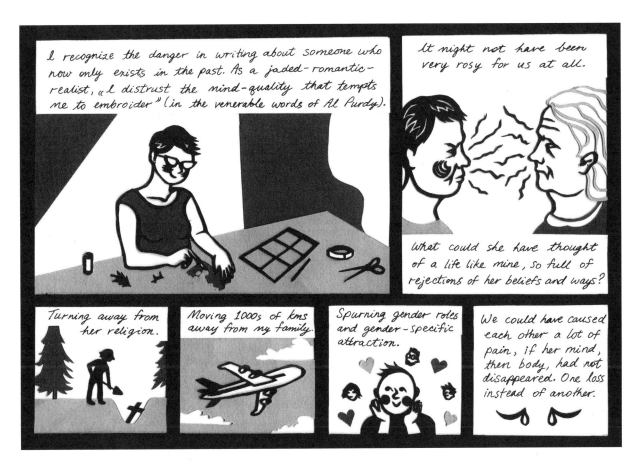

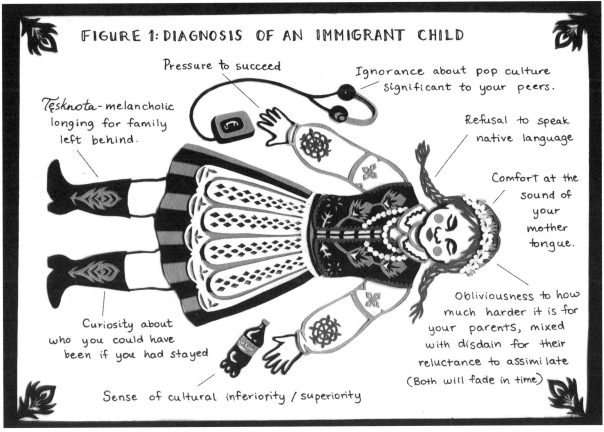

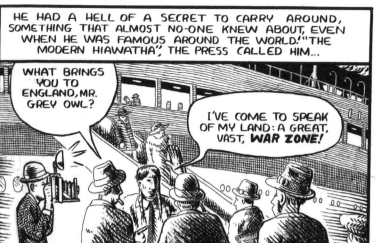

HE HAD A HELL OF A SECRET TO CARRY AROUND, SOMETHING THAT ALMOST NO-ONE KNEW ABOUT, EVEN WHEN HE WAS FAMOUS AROUND THE WORLD! "THE MODERN HIAWATHA", THE PRESS CALLED HIM...

WHAT BRINGS YOU TO ENGLAND, MR. GREY OWL?

I'VE COME TO SPEAK OF MY LAND: A GREAT, VAST, **WAR ZONE!**

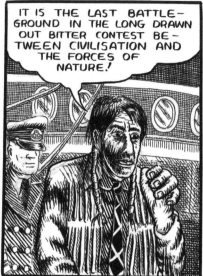

IT IS THE LAST BATTLE-GROUND IN THE LONG DRAWN OUT BITTER CONTEST BE-TWEEN CIVILISATION AND THE FORCES OF NATURE!

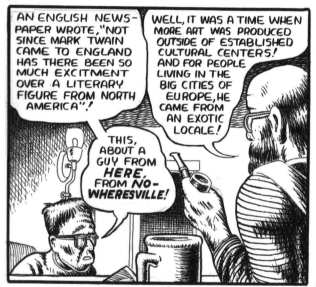

AN ENGLISH NEWS-PAPER WROTE, "NOT SINCE MARK TWAIN CAME TO ENGLAND HAS THERE BEEN SO MUCH EXCITMENT OVER A LITERARY FIGURE FROM NORTH AMERICA"!

WELL, IT WAS A TIME WHEN MORE ART WAS PRODUCED OUTSIDE OF ESTABLISHED CULTURAL CENTERS! AND FOR PEOPLE LIVING IN THE BIG CITIES OF EUROPE, HE CAME FROM AN EXOTIC LOCALE!

THIS, ABOUT A GUY FROM *HERE*, FROM *NO-WHERESVILLE!*

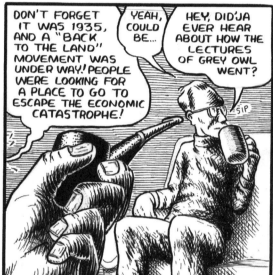

DON'T FORGET IT WAS 1935, AND A "BACK TO THE LAND" MOVEMENT WAS UNDER WAY! PEOPLE WERE LOOKING FOR A PLACE TO GO TO ESCAPE THE ECONOMIC CATASTROPHE!

YEAH, COULD BE...

HEY, DID'JA EVER HEAR ABOUT HOW THE LECTURES OF GREY OWL WENT?

SIP

THEY'D ALWAYS START OFF WITH A SWAYING ORGANIST PLAYING "MOONLIGHT SONATA" AT THE SIDE OF A DARKENED STAGE! THEN, SUDDENLY, CLIPS FROM NEWSREELS WOULD BE THROWN UP ON A SCREEN! THE FILM WAS A COLLECTION OF QUICK CUTS-LIKE SOME KIND OF 1930's MTV VIDEO! THIS WAS "CIVILISATION", FAMILIAR TO EVERYONE, EPITOMISED...

David Collier
The Life of Grey Owl, 1993

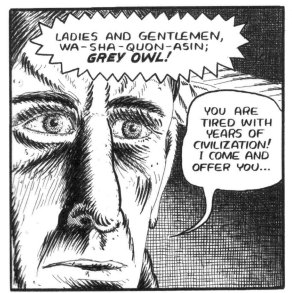

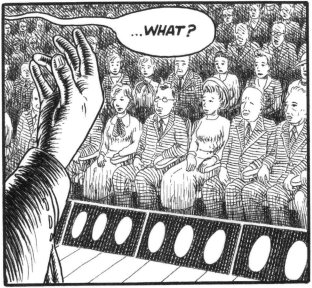

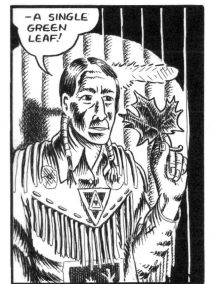

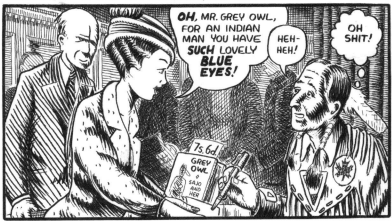

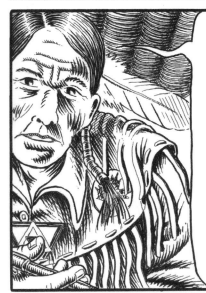

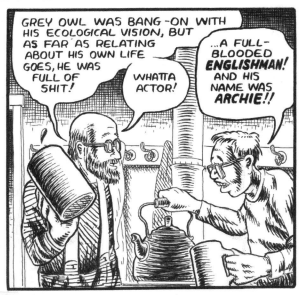

David Collier
The Life of Grey Owl, 1993

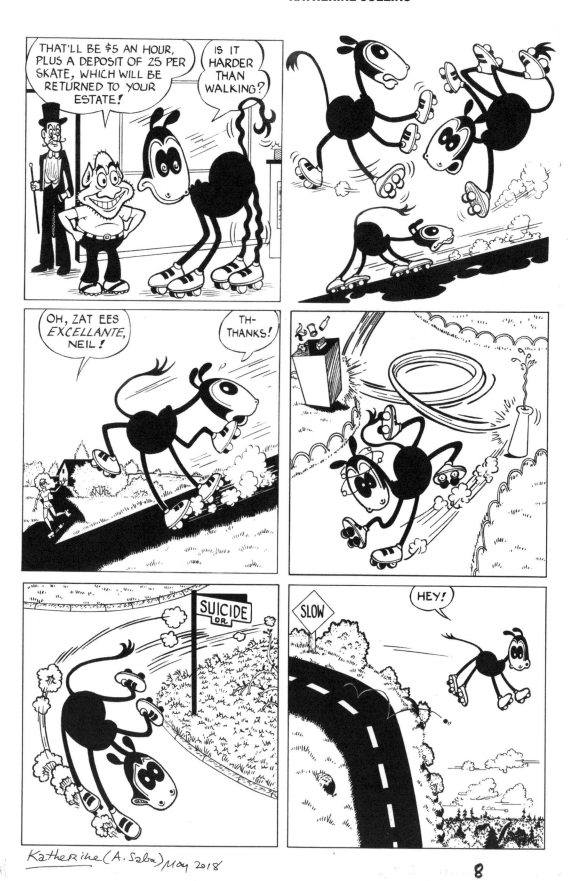

Katherine Collins
Neil the Horse #3, 1982

MICHAEL DEFORGE

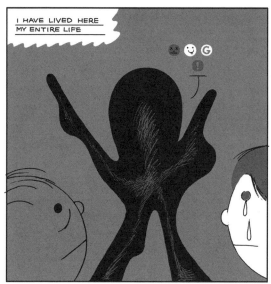

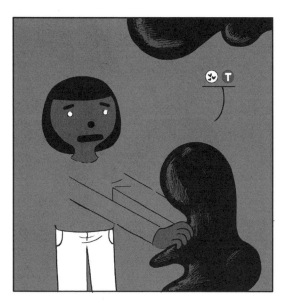

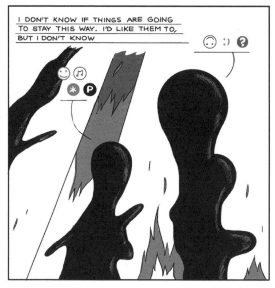

Michael DeForge
Placeholders, 2017

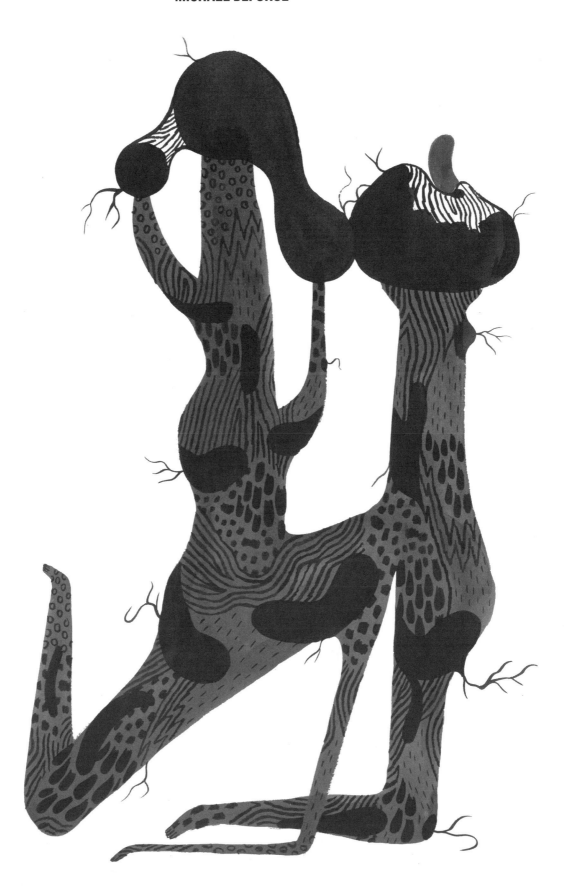

Michael DeForge
Dog, 2015

Julie Delporte
Moi aussi je voulais l'emporter, 2017

I discover the charming mökkis,
little wooden cabins where Finns
spend their summers and weekends.

Jérôme is far away
– I feel alone

he tells me there should be
fold-and-pack cabins,
take-away houses that shelter you
wherever you go.

Julie Delporte
Moi aussi je voulais l'emporter, 2017

Aminder Dhaliwal
Woman World, 2017

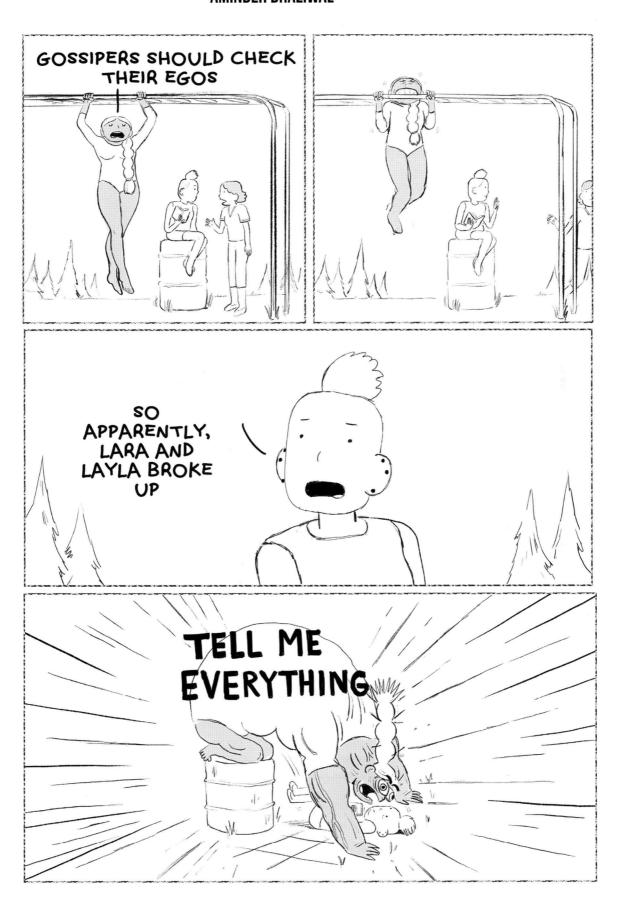

Aminder Dhaliwal
Woman World, 2017

JULIE DOUCET

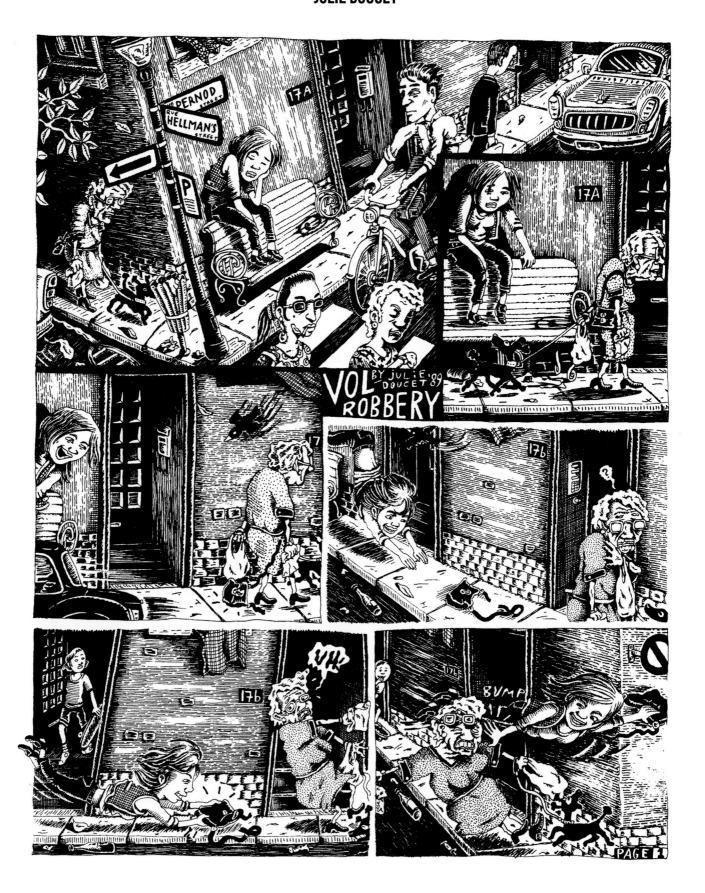

Julie Doucet
Vol/Robbery, 1989

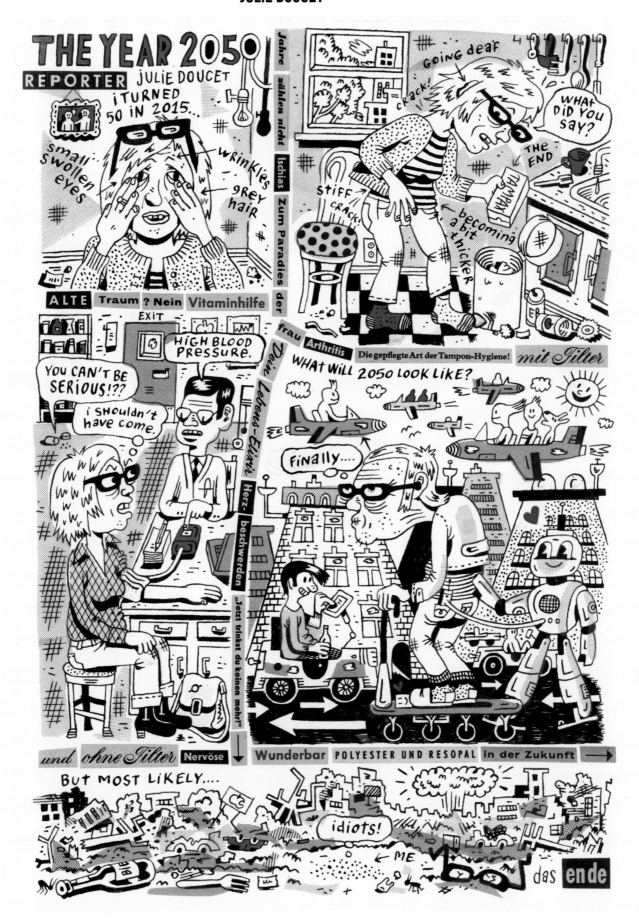

Julie Doucet
Das Jahr 2050, 2017

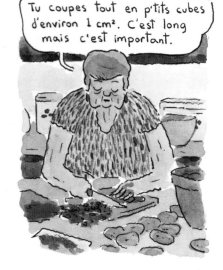

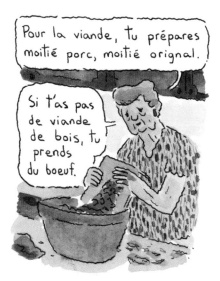

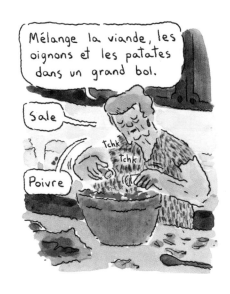

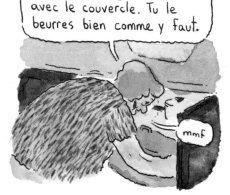

Pascal Girard
Untitled Book Project, 2018

PASCAL GIRARD

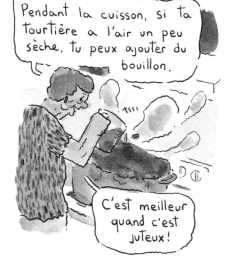

Pascal Girard
Untitled Book Project, 2018

MANY LEFTISTS SAW THE WAR AS HAVING THE POTENTIAL FOR **REVOLUTIONARY STRUGGLE**, AND IT CREATED A **MAJOR DIVISION** IN THE LEFT.

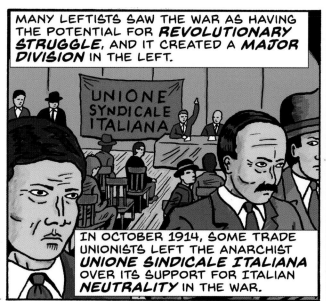

IN OCTOBER 1914, SOME TRADE UNIONISTS LEFT THE ANARCHIST **UNIONE SINDICALE ITALIANA** OVER ITS SUPPORT FOR ITALIAN **NEUTRALITY** IN THE WAR.

THESE MEMBERS FORMED THE **FASCI D'AZIONE RIVOLUZIONARIA INTERNAZIONALISTA**, A GROUP THAT MUSSOLINI JOINED SOON AFTER...

...AND THAT HE **QUICKLY** TOOK **CONTROL** OF.

IN ANCIENT ROME, THE **FASCES** (LATIN) WAS A BUNDLE OF WOODEN RODS WITH AN AXE HEAD PROTRUDING. IT WAS CARRIED BY **LICTORS**, THE BODYGUARDS TO ROMAN MAGISTRATES...

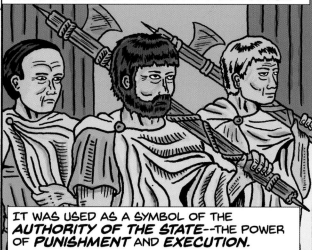

IT WAS USED AS A SYMBOL OF THE **AUTHORITY OF THE STATE**--THE POWER OF **PUNISHMENT** AND **EXECUTION**.

DURING THE 19TH CENTURY, THE **FASCIO** WAS ADOPTED BY RADICAL DEMOCRATS IN SICILY AS A SYMBOL OF **STRENGTH** AND **UNITY**. IT BECAME A COMMON TERM FOR A **GROUP** OR **LEAGUE** IN ITALY...

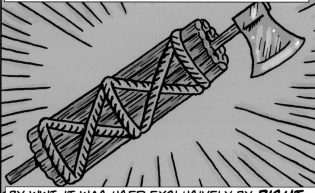

BY WWI, IT WAS USED EXCLUSIVELY BY **RIGHT-WING NATIONALISTS** DEMANDING ITALY JOIN THE WAR.

AFTER GAINING **CONTROL**, MUSSOLINI TRANSFORMED THE FASCI INTO A RIGHT-WING NATIONALIST GROUP, DENOUNCING **MARXISM** AS A FAILURE BUT STILL ALLUDING TO **ANTI-CAPITALIST** AND **SOCIALIST** BELIEFS.

IN 1915, HOWEVER, MUSSOLINI WAS **DRAFTED** INTO THE ARMY AND SENT TO THE **FRONT**.

HE SERVED IN AN **INFANTRY REGIMENT** AND SAW **COMBAT** ALONG THE ITALIAN AND AUSTRIA-HUNGARIAN BORDER.

Gord Hill
The Antifa Comic Book, 2018

ITALY HAD **ENTERED** THE WAR ON THE SIDE OF THE BRITISH AND FRENCH, AND HAD BEEN PROMISED **TERRITORIAL GAINS** IN EXCHANGE...

ITALY SUFFERED **600,000 DEAD**, AND OVER **900,000 INJURED**.

BUT AFTER THE WAR ENDED, IN **NOVEMBER 1918**, ITALY WAS **DENIED** MOST OF THE LAND PROMISED. THIS WAS FORMALIZED IN THE **PARIS PEACE CONFERENCE** (1919).

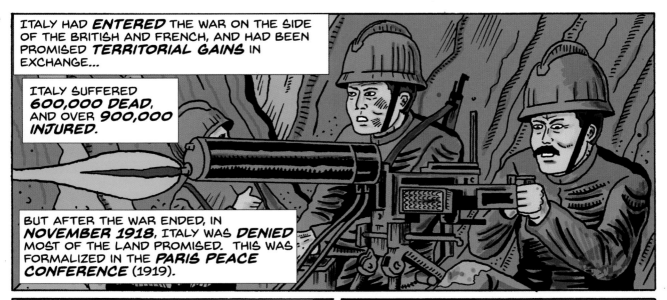

POST-WAR ITALY FACED A SOCIO-ECONOMIC **CRISIS**: MASSIVE **DEBT**, HIGH **UNEMPLOYMENT**, **POVERTY**, AND **3 MILLION DEMOBILIZED SOLDIERS**.

MANY OF THESE SOLDIERS, AND MOST ITALIANS, WERE ALSO **ANGERED** BY THE PARIS PEACE SETTLEMENT. ALL THESE FACTORS CREATED MORE POLITICAL **INSTABILITY** AND **UNCERTAINTY**.

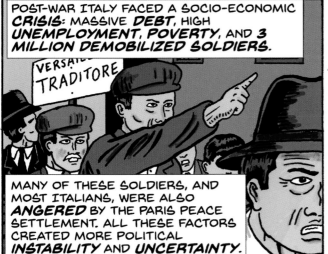

INSPIRED BY THE **1917 RUSSIAN REVOLUTION**, RADICALS ACROSS EUROPE SAW THESE CRISES AS OPPORTUNITIES FOR **REVOLUTIONS**.

MILLIONS OF WORKERS JOINED COMMUNIST, SOCIALIST, OR ANARCHIST GROUPS. A WAVE OF **REBELLION** SWEPT ACROSS EUROPE.

THE SOCIALIST PARTY GREW FROM **50,000** IN 1914 TO OVER **200,000** IN 1919. DURING ELECTIONS IN 1919, THE P.S.I. WON **1.8 MILLION** VOTES (32%). IF NOT FOR THE INABILITY TO FORM A COALITION, THE P.S.I. WOULD HAVE **WON**.

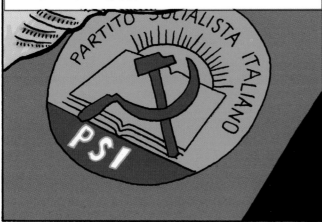

THE MAIN SOCIALIST TRADE UNION, THE GENERAL CONFEDERATION OF LABOUR, GREW TO **2 MILLION** MEMBERS. THE ANARCHIST UNIONE SINDICALE ITALIANA HAD UP TO **500,000** MEMBERS...

Gord Hill
The Antifa Comic Book, 2018

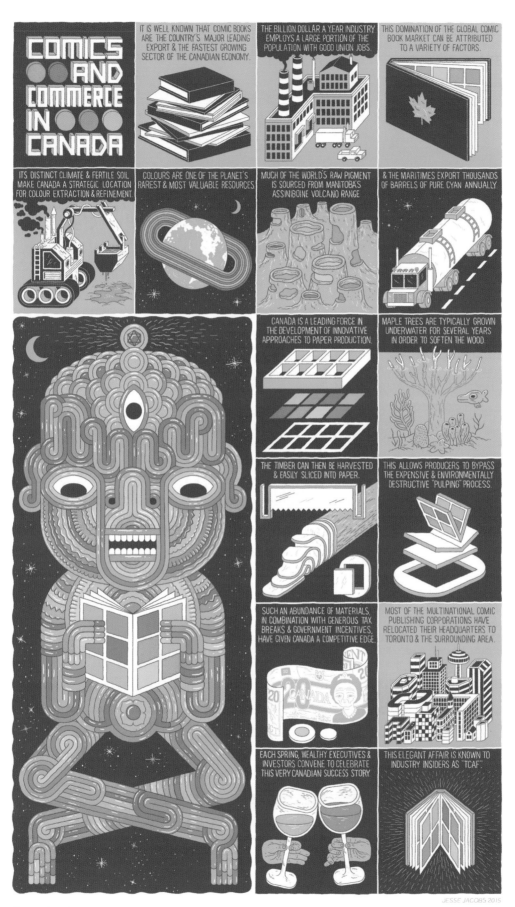

Jesse Jacobs

Comics and Commerce in Canada (TCAF), Commissioned for the *National Post*, 2015

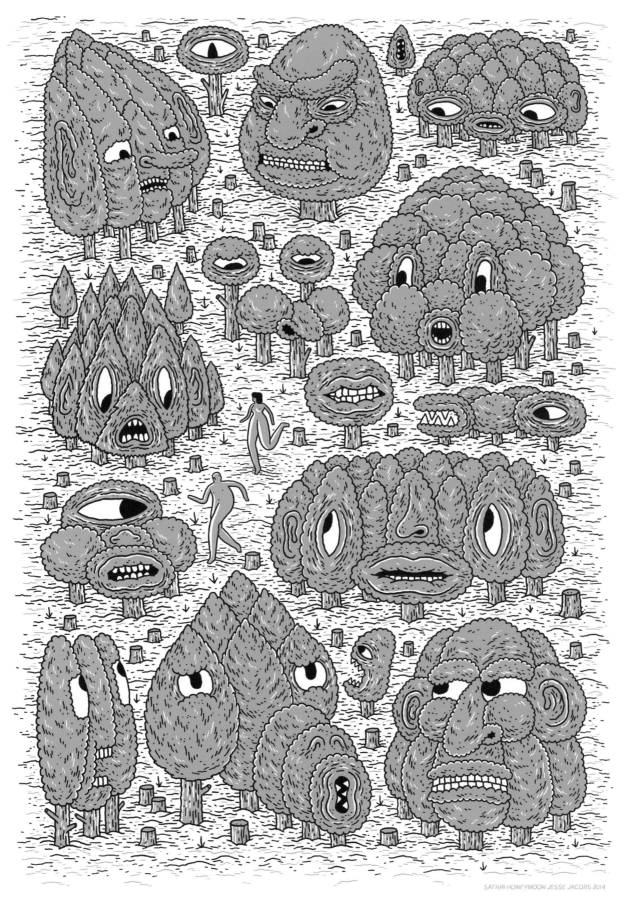

Jesse Jacobs
Safari Honeymoon 3, 2014

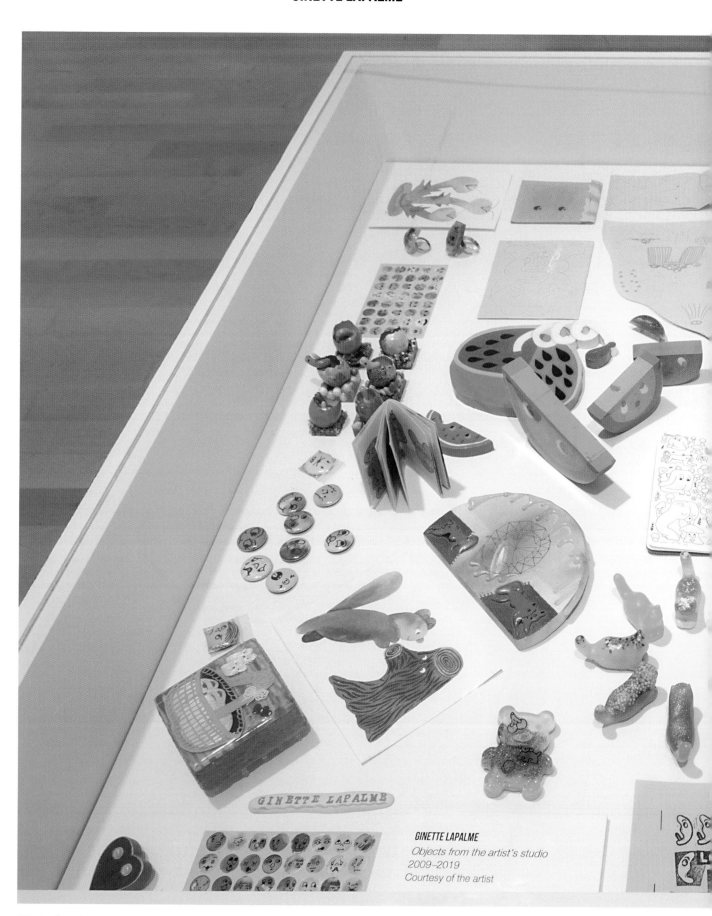

Ginette Lapalme
Installation view: *Objects from the artist's studio,* 2009–19

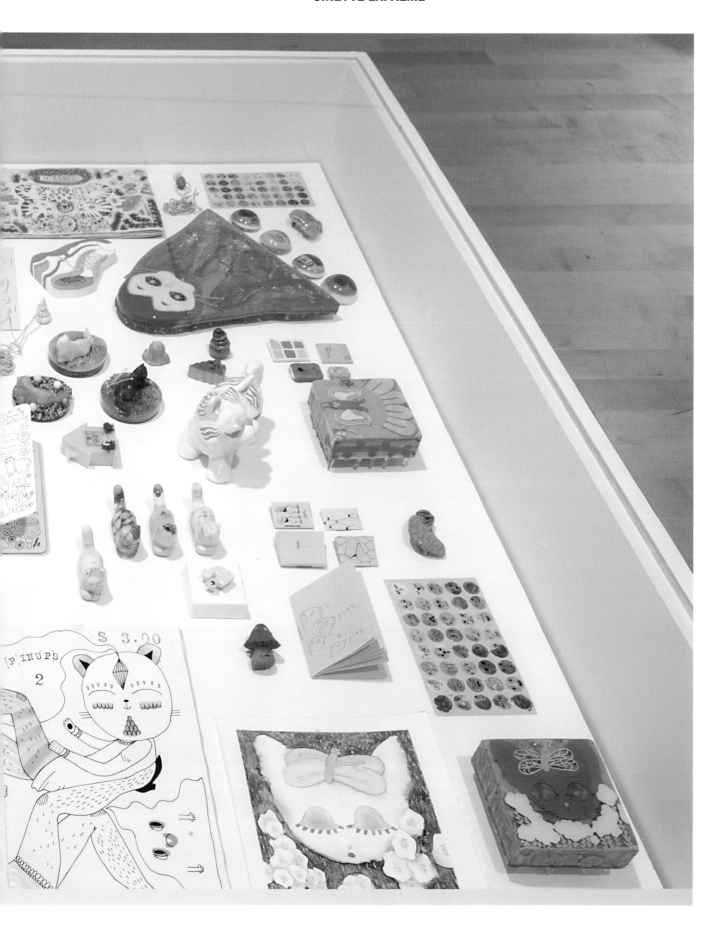

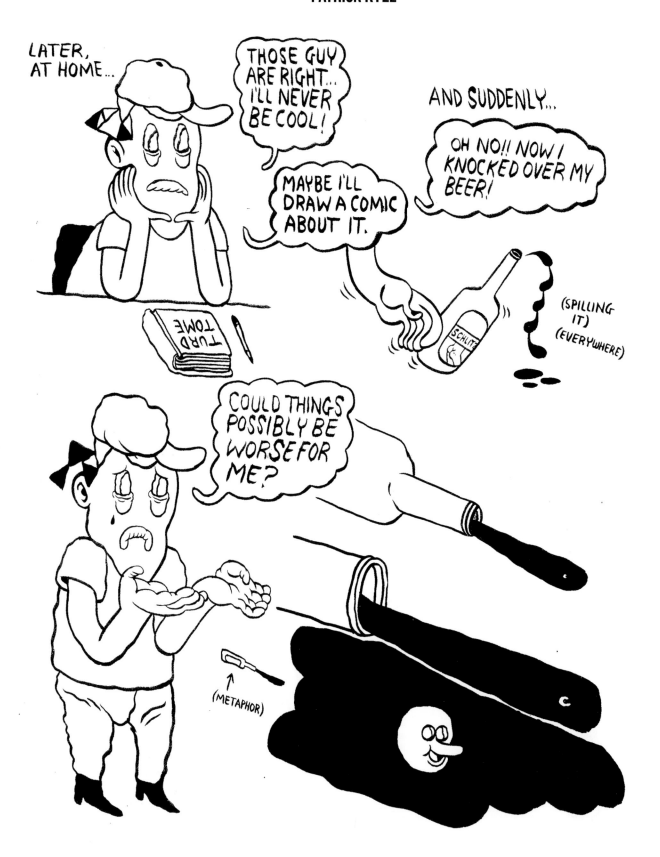

Patrick Kyle
Black Mass, 2009

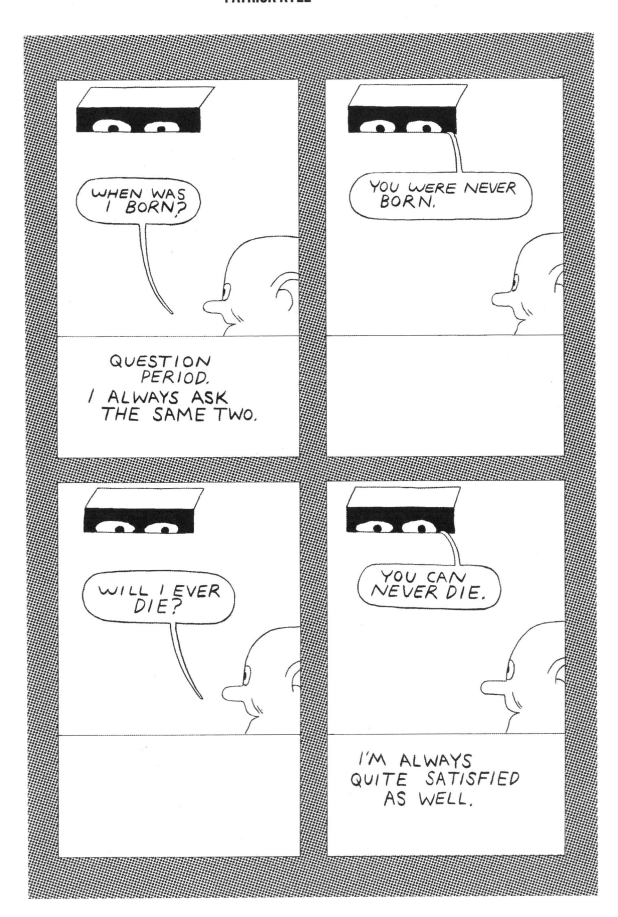

Patrick Kyle
Everywhere Disappeared, 2017

Ness Lee
And now, to see what I feel, 2019

NESS LEE

Ness Lee
Concept drawing for *And now, to see what I feel*, 2019

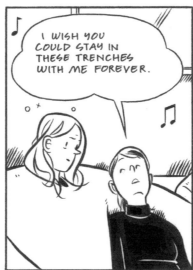

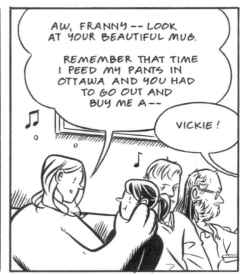

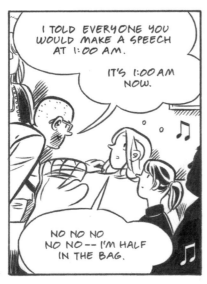

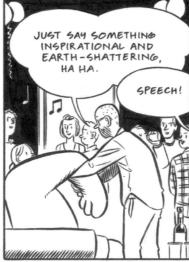

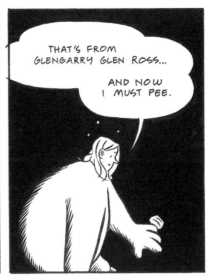

Hartley Lin
Young Frances, 2018

Billy Mavreas
City Face, 2001

Billy Mavreas
City Face, 2001

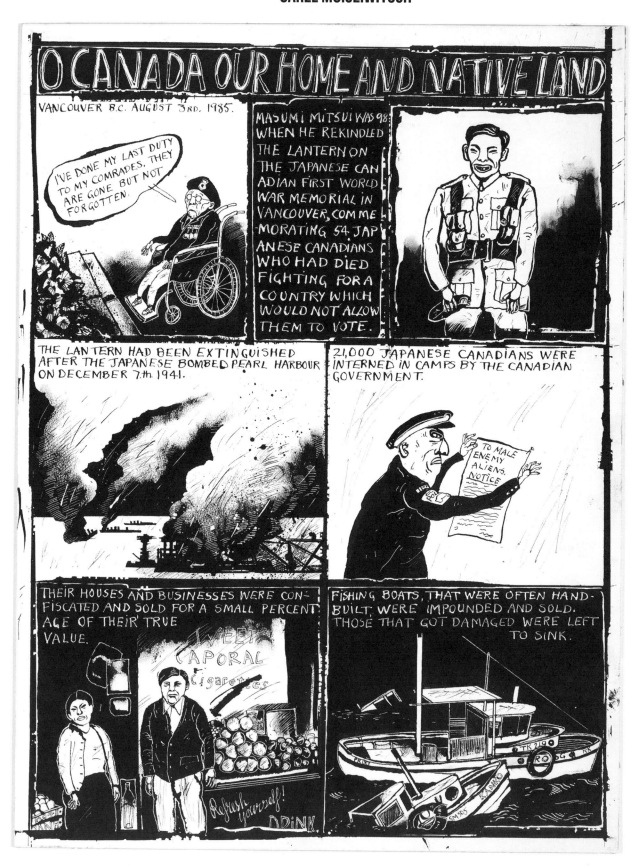

Carel Moiseiwitsch

Oh Canada Our Home and Native Land, 1985

CAREL MOISEIWITSCH

Carel Moiseiwitsch
Oh Canada Our Home and Native Land, 1985

SYLVIA NICKERSON

In Pickering, the nuclear industry stores radioactive waste just two kilometres from some homes.

In Hamilton, I live less than two kilometres from toxic waste.*

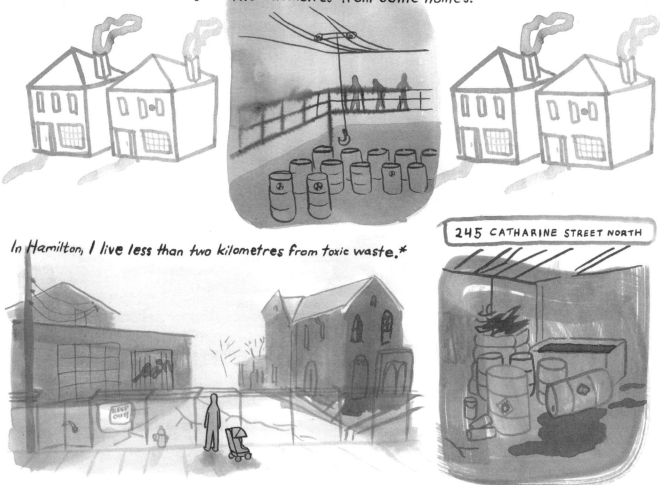

245 CATHARINE STREET NORTH

Hell, I might even live across the street from toxic waste, for all I know.

FOUNDRY / KNITTING AND DYEING COMPANY

FORMER WELDING COMPANY

FORMER MACHINE SHOP

*FORMER SITE OF JOYCE & SMITH ELECTRO-PLATING CO. LTD., 245 CATHARINE STREET NORTH CONTAINS 200,000 - 300,000 LITRES OF CORROSIVE CHEMICALS IN OPEN TANKS, BARRELS, VATS AND A PIT. RAINWATER SPILLS IN THROUGH HOLES IN THE ROOF. THE PROPERTY OWNER PAYS A MAN $10 A DAY TO LIVE ON THE SITE AND SIPHON THIS **WASTE INTO THE SEWER.**

Sylvia Nickerson
Creation, 2016–18

SYLVIA NICKERSON

Now my dad has lymphoma, and my mom had breast cancer. Things aren't how they were supposed to be.

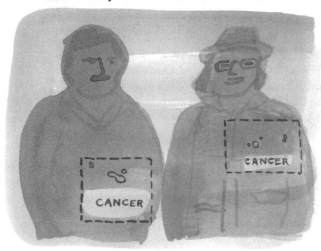

When I was twenty-six, my grandfather died at age ninety.

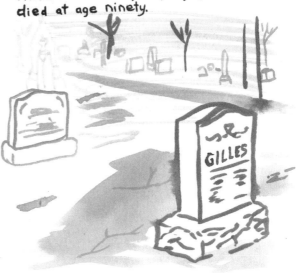

At the rate things are going now

I'll probably have two cancers

by the time I'm forty.

Who knows what will happen

to Toby,

Sylvia Nickerson
Creation, 2016–18

DIANE OBOMSAWIN

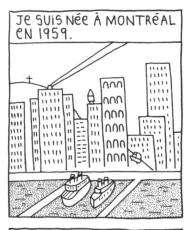

JE SUIS NÉE À MONTRÉAL EN 1959.

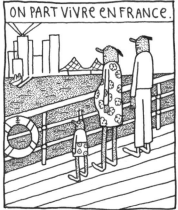

ON PART VIVRE EN FRANCE.

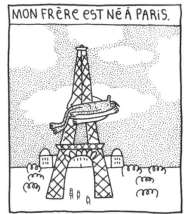

MON FRÈRE EST NÉ À PARIS.

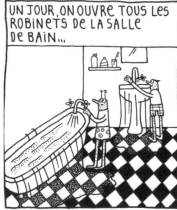

UN JOUR, ON OUVRE TOUS LES ROBINETS DE LA SALLE DE BAIN...

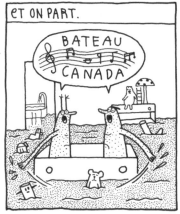

ET ON PART.

BATEAU CANADA

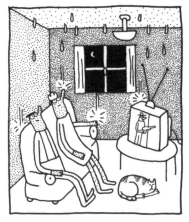

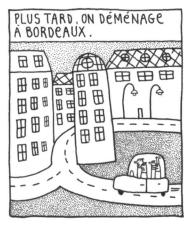

PLUS TARD, ON DÉMÉNAGE À BORDEAUX.

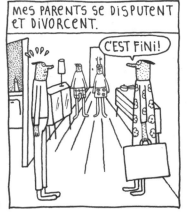

MES PARENTS SE DISPUTENT ET DIVORCENT.

C'EST FINI!

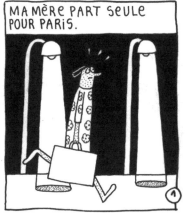

MA MÈRE PART SEULE POUR PARIS.

Diane Obomsawin
Ici par ici, 2003

DIANE OBOMSAWIN

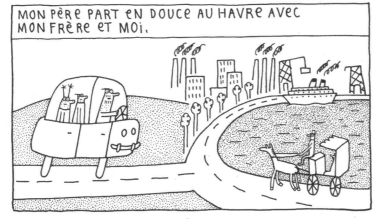

MON PÈRE PART EN DOUCE AU HAVRE AVEC MON FRÈRE ET MOI.

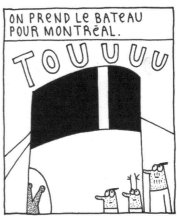

ON PREND LE BATEAU POUR MONTRÉAL.

TOUUUU

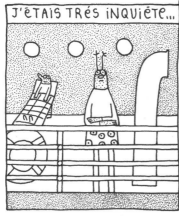

J'ÉTAIS TRÈS INQUIÈTE...

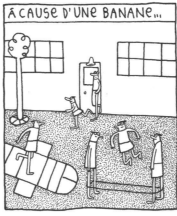

À CAUSE D'UNE BANANE...

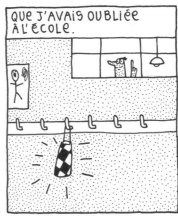

QUE J'AVAIS OUBLIÉE À L'ÉCOLE.

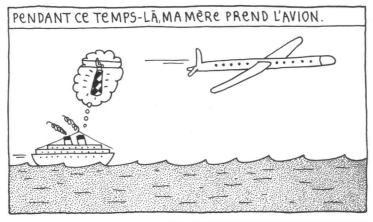

PENDANT CE TEMPS-LÀ, MA MÈRE PREND L'AVION.

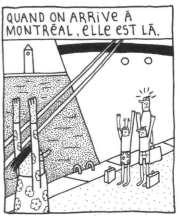

QUAND ON ARRIVE À MONTRÉAL, ELLE EST LÀ.

MES PARENTS DISCUTENT ABONDAMMENT

ET MA MÈRE REPART SEULE POUR PARIS.

J'AI LONGTEMPS PENSÉ QUE C'ÉTAIT ELLE SUR LES PAQUETS DE CIGARETTES.

②

Diane Obomsawin
Ici par ici, 2003

BUT WHERE DO WE START? FOR WELL OVER A CENTURY POWERFUL INTERESTS HAVE BEEN SHAPING OUR DESIRES, HOPES, DREAMS AND EXPERIENCES ACCORDING TO THE LOGIC OF PETRO-CARBONS.

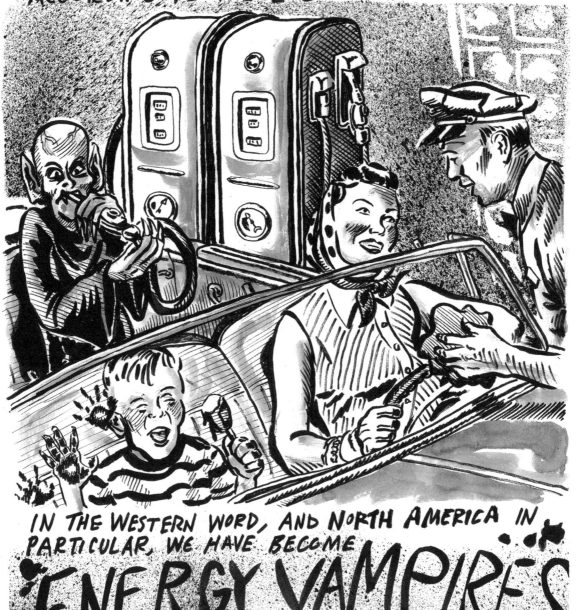

IN THE WESTERN WORD, AND NORTH AMERICA IN PARTICULAR, WE HAVE BECOME ENERGY VAMPIRES

SUCKING UP MORE THAN OUR FAIR SHARE OF ENERGY RESOURCES IN PURSUIT OF LIFESTYLES THAT RARELY DELIVER ON THE PROMISES OF PROSPERITY AND HAPPINESS THAT ARE SOLD TO US.

Simon Orpana
The Petrocultures of Everyday Life, 2018

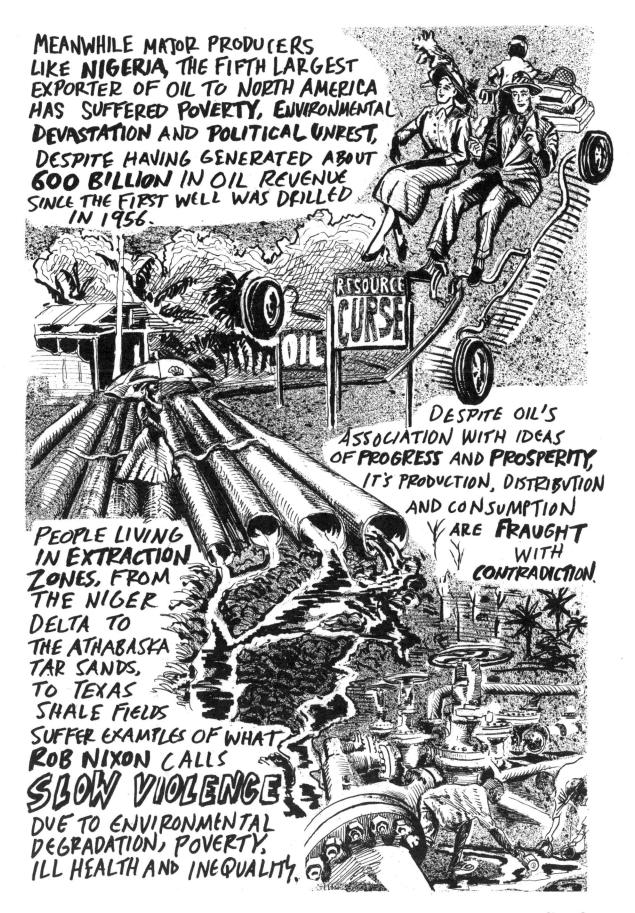

MEANWHILE MAJOR PRODUCERS LIKE **NIGERIA**, THE FIFTH LARGEST EXPORTER OF OIL TO NORTH AMERICA HAS SUFFERED **POVERTY**, **ENVIRONMENTAL DEVASTATION** AND **POLITICAL UNREST**, DESPITE HAVING GENERATED ABOUT **600 BILLION** IN OIL REVENUE SINCE THE FIRST WELL WAS DRILLED IN 1956.

RESOURCE CURSE

OIL

DESPITE OIL'S ASSOCIATION WITH IDEAS OF **PROGRESS** AND **PROSPERITY**, IT'S PRODUCTION, DISTRIBUTION AND CONSUMPTION ARE **FRAUGHT** WITH **CONTRADICTION**.

PEOPLE LIVING IN **EXTRACTION ZONES**, FROM THE NIGER DELTA TO THE ATHABASKA TAR SANDS, TO TEXAS SHALE FIELDS SUFFER EXAMPLES OF WHAT **ROB NIXON** CALLS **SLOW VIOLENCE** DUE TO ENVIRONMENTAL DEGRADATION, POVERTY, ILL HEALTH AND INEQUALITY.

Simon Orpana
The Petrocultures of Everyday Life, 2018

MEREDITH W. PARK

Meredith W. Park
Hamilton: A City in Transition, 2017

MEREDITH W. PARK

I NEVER DREAMED OF BEING A CITY DWELLER, BUT I'VE BECOME ONE.

I RELISH THE DEPENDENCE I NOW HAVE, ON MY OWN BODY AND THE BODY OF THE CITY, IN ORDER TO GET BY & LIVE

(I SEE NOW THAT A LOT OF LIFE IS JUST GETTING BY, MUCH AS WE'D ALL LOVE MORE MEANINGFUL DAYS. SO IT GOES.)

HAVING STUDIED THE NATURE AND PURPOSE OF CITIES, I AM STILL EVER FASCINATED...

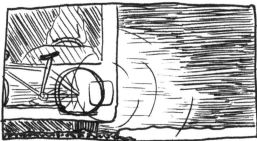

BY SECRET PLACES. HIDDEN GATHERING SPOTS. INDUSTRIAL INTIMACY.

LATELY THOUGH, I AM MOST INTERESTED IN THE EMPTY PARTS OF CITIES.

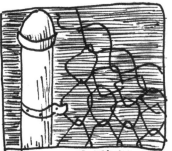

WE THINK CITIES ARE FOR US. THEY HAVE PLACES BUILT SO NO HUMAN INTRUDES.

IT IS STRANGE TO THINK THAT THIS LIFE-SUSTAINING ORGANISM REQUIRES PARTS THAT WE CANNOT TOUCH, AND FORBIDDEN ENCLAVES. BUT I SUPPOSE OUR BODIES & MINDS ARE SIMILAR. I FEEL LIKE A GHOST WHEN ON AN EMPTY LOT

Meredith W. Park
Sketchbook, 2015

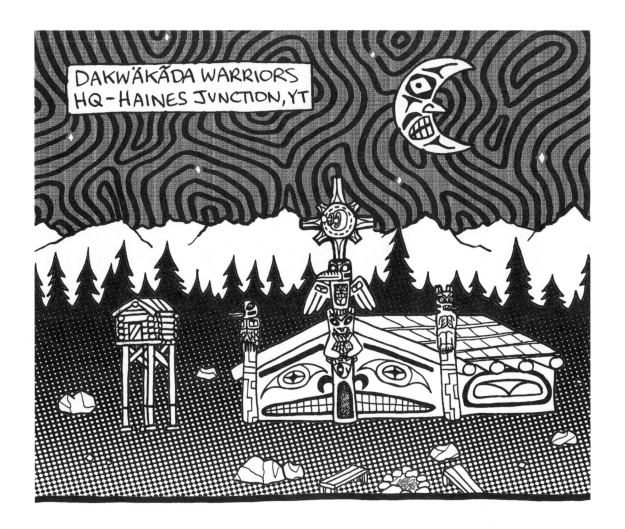

Cole Pauls
Dakwäkãda Warriors II, 2017

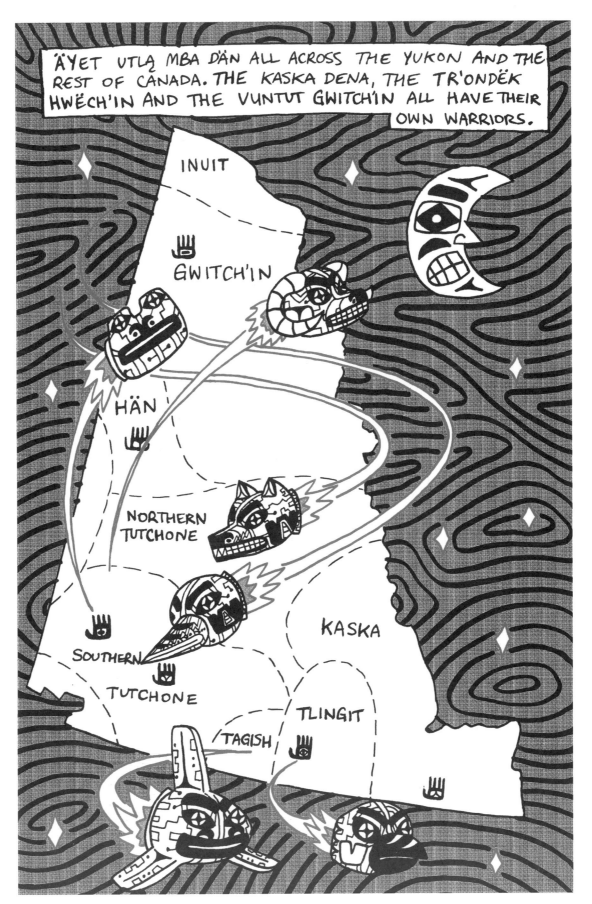

Cole Pauls
Dakwäkäda Warriors III, 2018

Living without hydro

In JULY I moved into an apart-ment

The landlord was there, painting in the dark

He told me that Hydro had been cut off the day before

... Despite an agreement he had with them

I looked at the fridge and thought about the Hydra it used.

That fridge would run night and day, sometimes to chill just one small carton of milk.

So I decided to go without Hydro for as long as I could.

7 months later I keep my milk cold between the doors...

... and have candle-lit dinners every night. THE END

GP 06

Gord Pullar
Living without Hydro, 2006

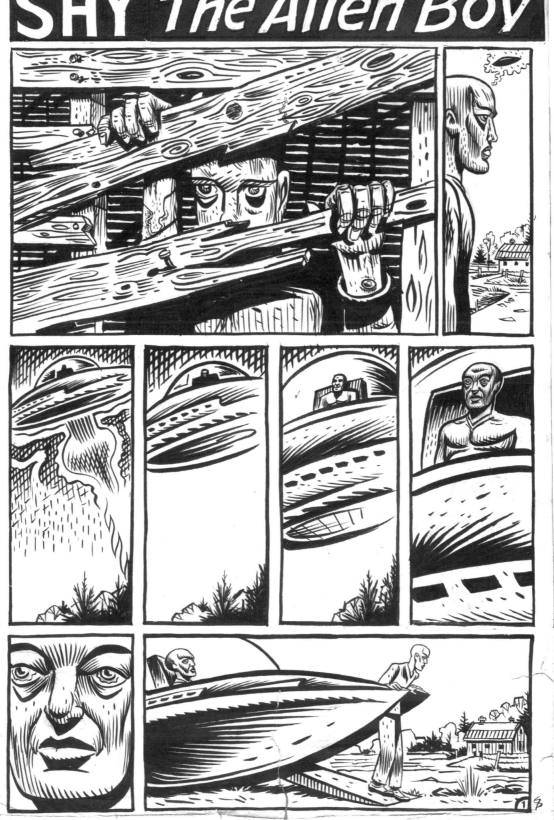

Gord Pullar
Shy the Alien Boy, 2000

J'ÉTAIS TRÈS ATTIRÉ PAR CES DESSINS. SURTOUT CEUX DE ROBERT LA PALME.

JE TROUVAIS QUE SES CARICATURES AVAIENT UN *SWING* INCROYABLE. POUR MOI, IL RESTE ENCORE UN DES MEILLEURS À CE JOUR.

WOW...

IL Y AVAIT AUSSI QUELQUES PLANCHES ORIGINALES DE BANDES DESSINÉES EUROPÉENNES ET CANADIENNES QUE JE CONNAISSAIS.

Peyo - (Belgique) Les Schtroumpfs

Jean Graton (Belgique) Michel Vaillant

COMMENT FONT-ILS?

Albert Chartier (Canada) Ohésime

ONÉSIME

VIENS-T'EN DONC, C'EST PLATE ICI...

ENCORE UNE MINUTE.

CETTE EXPO M'AVAIT FORT IMPRESSIONNÉ. VOIR DES ORIGINAUX FAITS AVEC DE L'ENCRE SUR DU PAPIER À DESSIN M'AVAIT FAIT RÉALISER QU'IL Y AVAIT DE VRAIES PERSONNES QUI TRAVAILLAIENT LÀ-DESSUS.

AU SECOURS!

TIENS TIENS... ILS RETOUCHENT LEURS GAFFES À LA PEINTURE BLANCHE...

CELA M'AVAIT DONNÉ ENVIE D'ESSAYER MOI AUSSI À LA MAISON.

Astérix LÉGIONNAIRE

PFF! PAS FACILE

J'AI COMMENCÉ PAR ESSAYER DE RECOPIER DES PERSONNAGES D'ASTÉRIX.

Michel Rabagliati
Paul dans le métro, 2005

MICHEL RABAGLIATI

Michel Rabagliati
Paul à la pêche, 2006

R.A. ROSEN

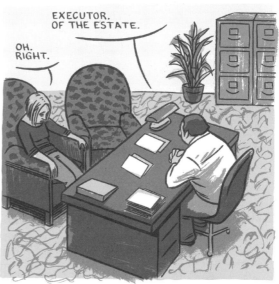

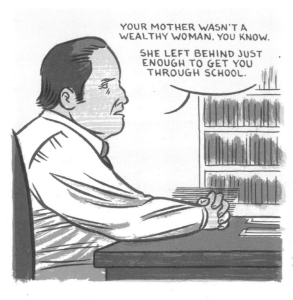

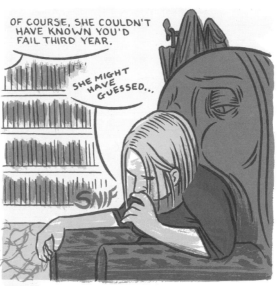

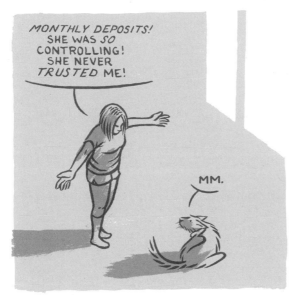

R.A. Rosen
Flem, 2018

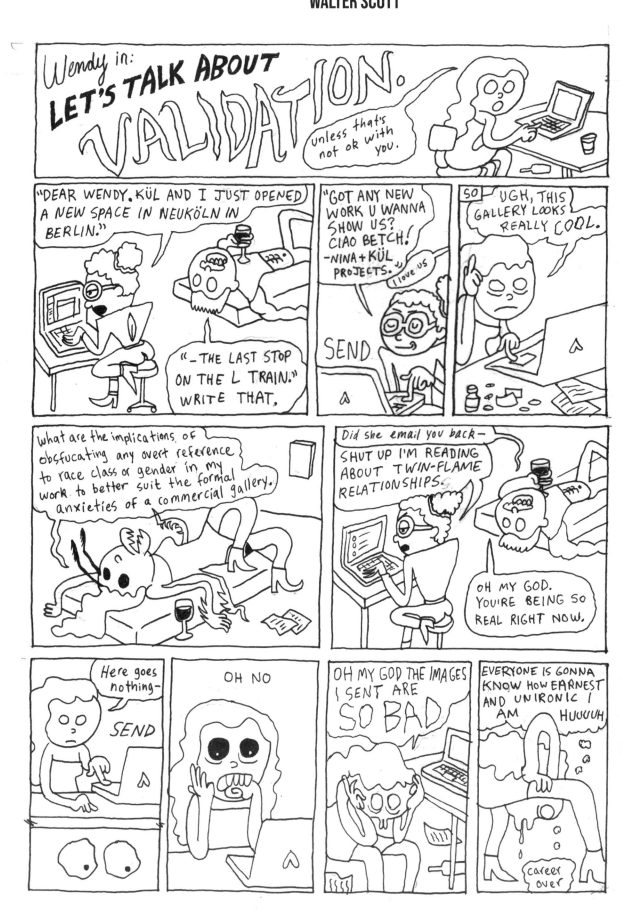

Walter Scott
Let's Talk About Validation, 2012

WALTER SCOTT

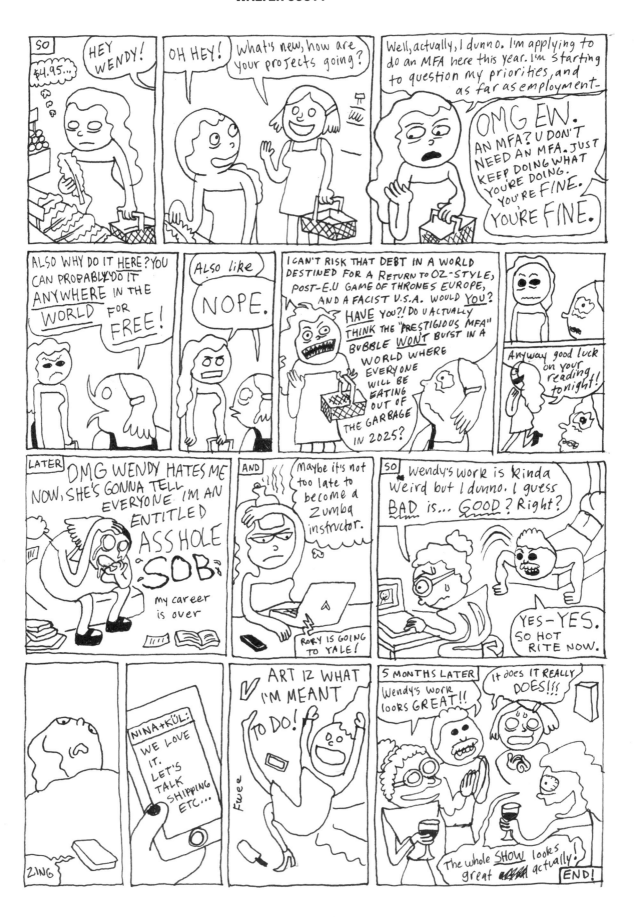

Walter Scott
Let's Talk About Validation, 2012

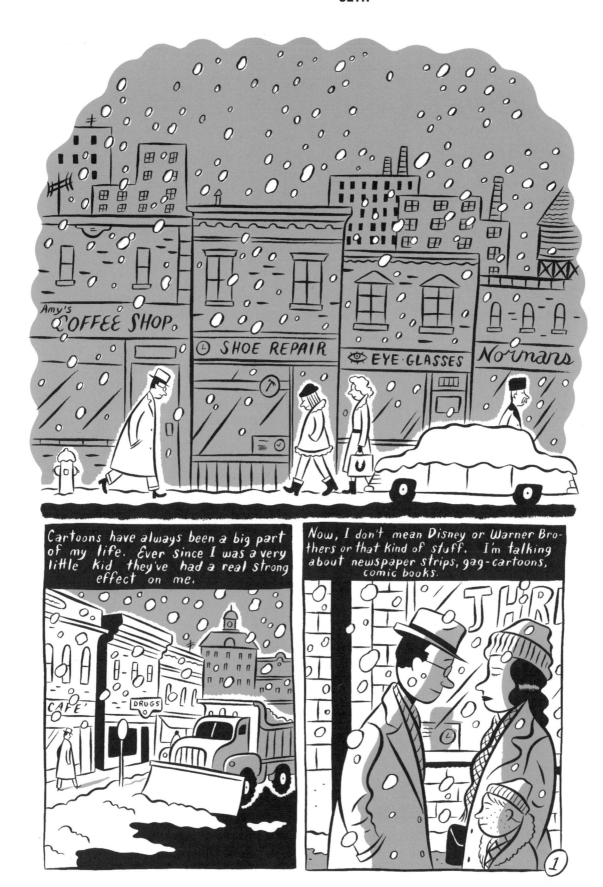

Seth

It's a Good Life if You Don't Weaken, 1993

They occupy a BIG part of my brain. It seems like I'm always relating things that happen to me back to some mouldy old comic gag or something like that.

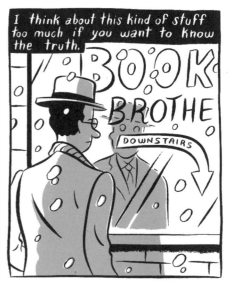

I think about this kind of stuff too much if you want to know the truth.

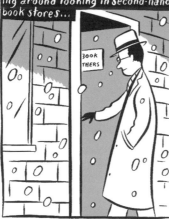

Take this day for example... Christmas of '86. I was visiting my family in London, Ont., walking around looking in second-hand book stores...

..and running around in my mind was an old Charlie Brown strip, a Sunday page I think-- a Snoopy one.

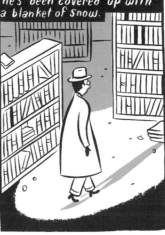

In it, he's sleeping on his dog-house and during the night he's been covered up with a blanket of snow.

So he wakes up, without disturbing the snow, and he's pissed off 'cause he won't be able to find his dog-dish etc. etc. Anyhow, it occurs to him that maybe he's not covered with snow-- maybe he's gone blind.

He panics for awhile and then he jumps up out of the snow and realizes he's not blind. In the last panel Snoopy's dancing and singing "Snow! Beautiful snow!"

Seth

It's a Good Life if You Don't Weaken, 1993

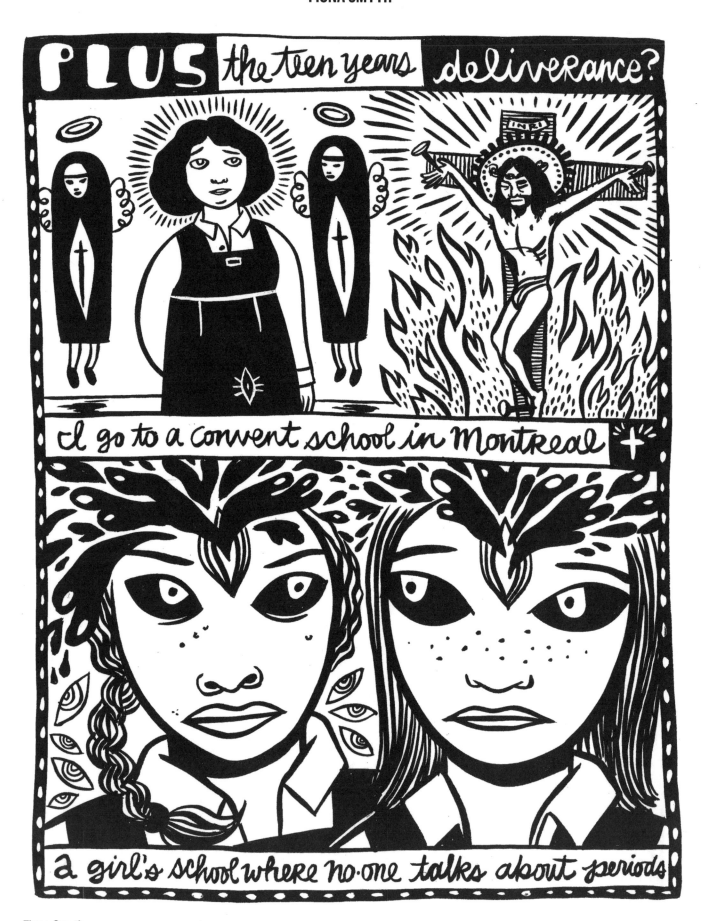

Fiona Smyth

The Teen Years: Deliverance, 1998

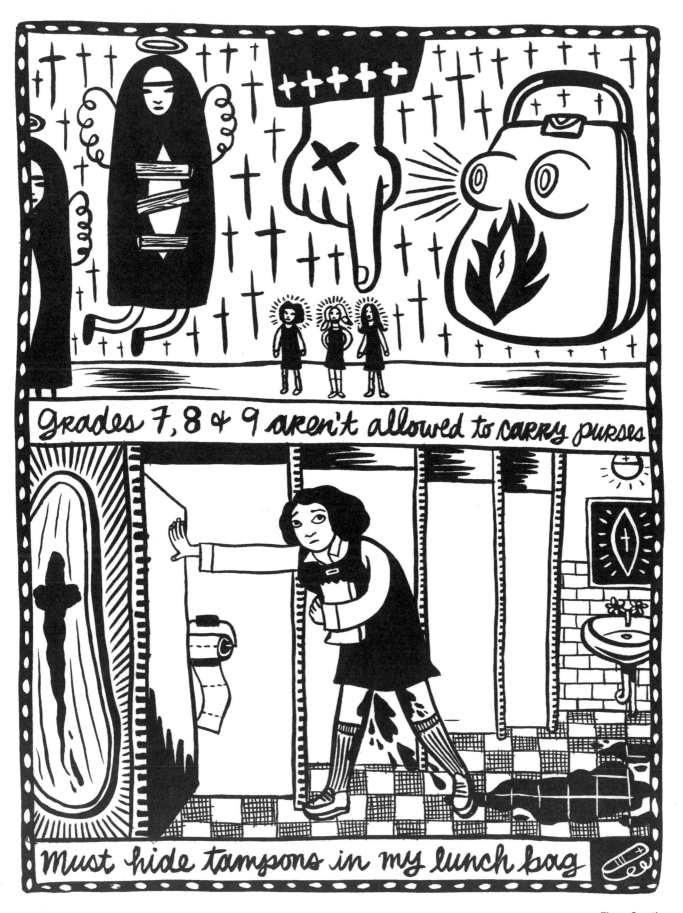

Fiona Smyth
The Teen Years: Deliverance, 1998

JILLIAN TAMAKI

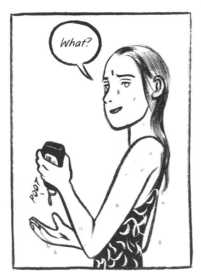
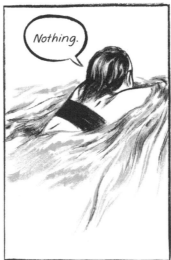
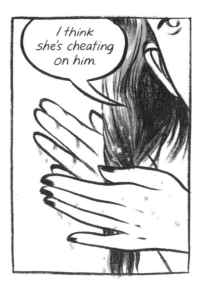

Jillian Tamaki
This One Summer, 2013

JILLIAN TAMAKI

Maurice Vellekoop
I'm So Glad We Had This Time Together, 2019

Maurice Vellekoop
I'm So Glad We Had This Time Together, 2019

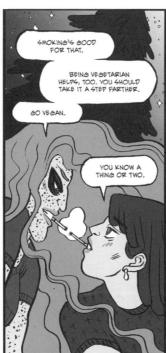
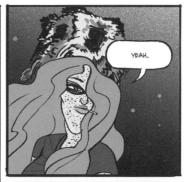
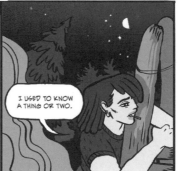

Kat Verhoeven
Meat and Bone, 2017–18

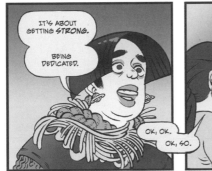

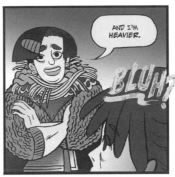
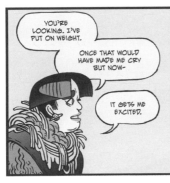

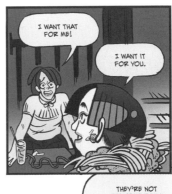
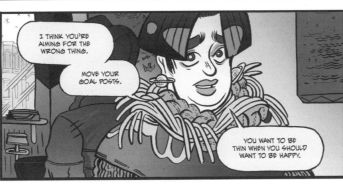
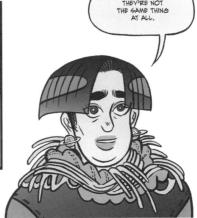

Kat Verhoeven
Meat and Bone, 2017–18

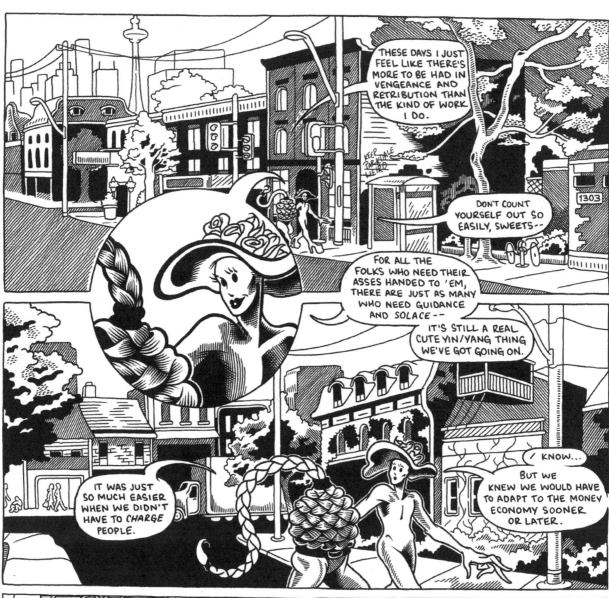

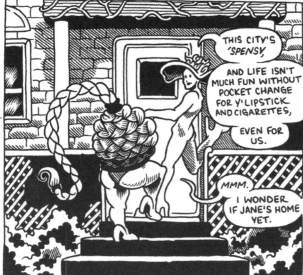

Eric Kostiuk Williams
Condo Heartbreak Disco, 2015

Eric Kostiuk Williams
Condo Heartbreak Disco, 2015

Connor Willumsen
Anti-Gone, 2016

Connor Willumsen
Anti-Gone, 2016

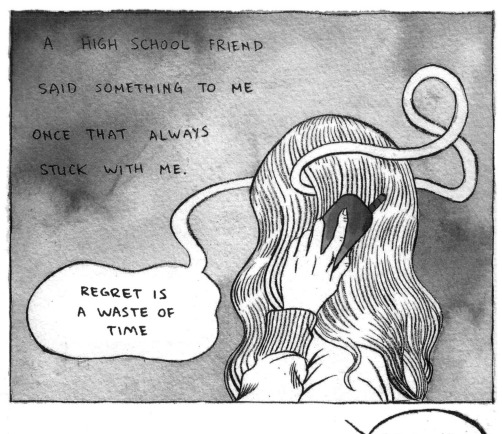

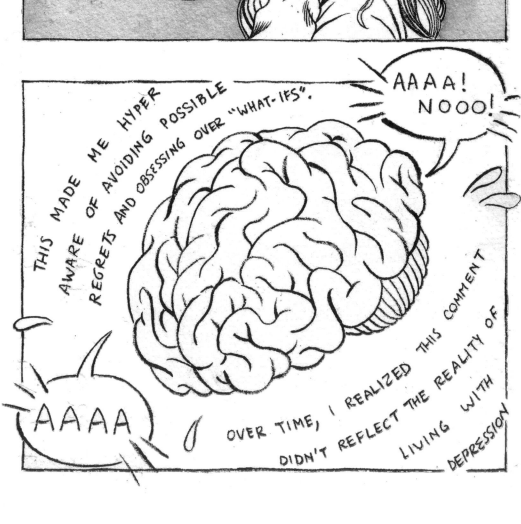

Jenn Woodall
Black Mood, 2016

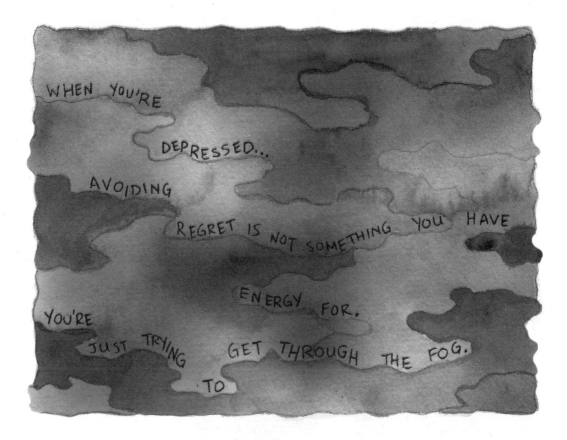

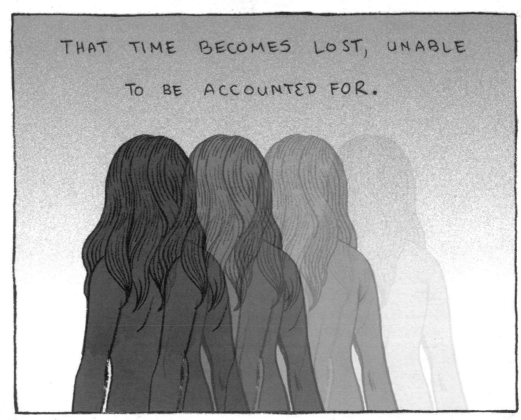

Jenn Woodall
Black Mood, 2016

HISTORICAL HAMILTON

BLAINE (BLAINE MACDONALD)

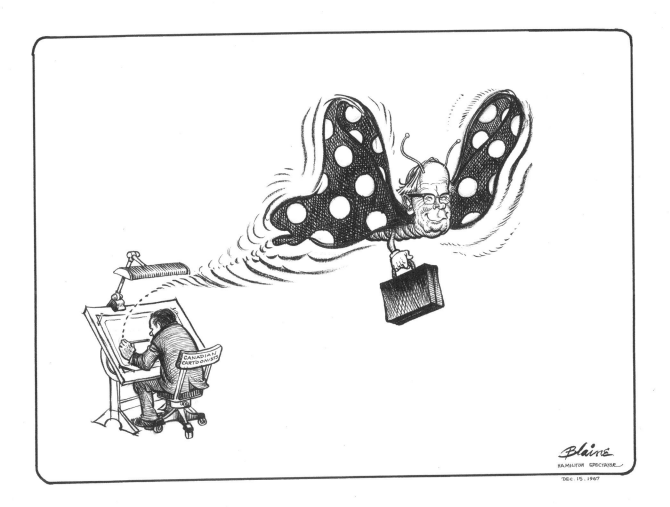

Blaine (Blaine MacDonald)
The Retirement of Prime Minister Lester B. Pearson, 1967
Library and Archives Canada

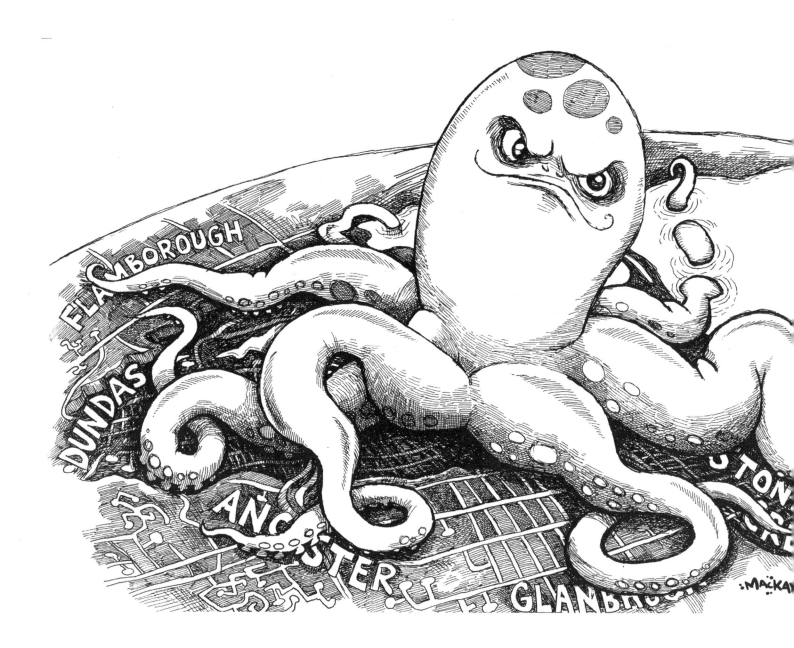

Graeme MacKay
Amalgamation octopus cartoon, 1999

Graeme MacKay
December 24, 2012, 2012

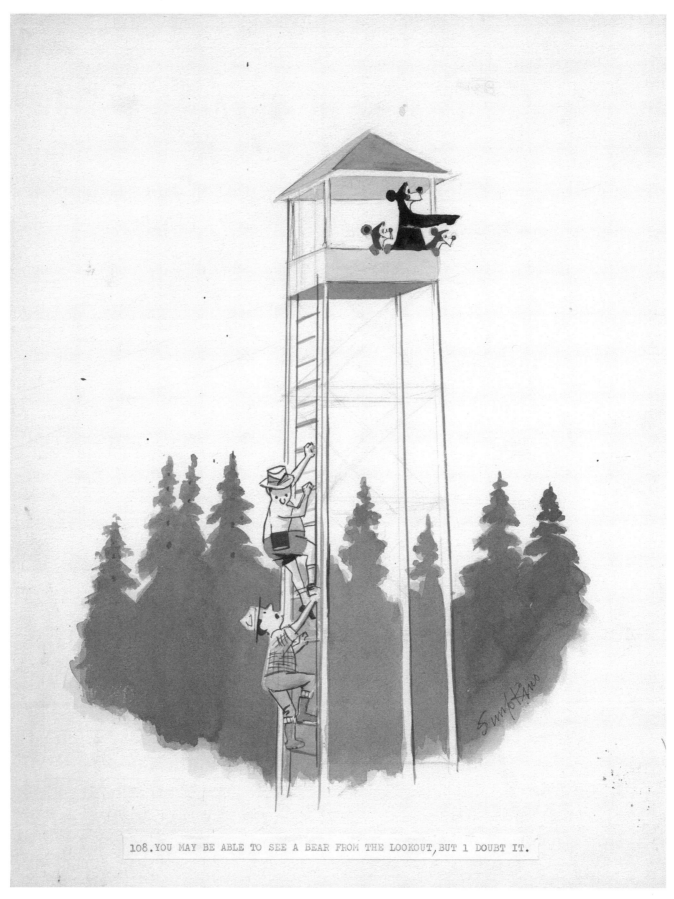

108. YOU MAY BE ABLE TO SEE A BEAR FROM THE LOOKOUT, BUT 1 DOUBT IT.

James (Jim) Simpkins
YOU MAY BE ABLE TO SEE A BEAR FROM THE LOOKOUT, BUT I DOUBT IT, 1965
Library and Archives Canada

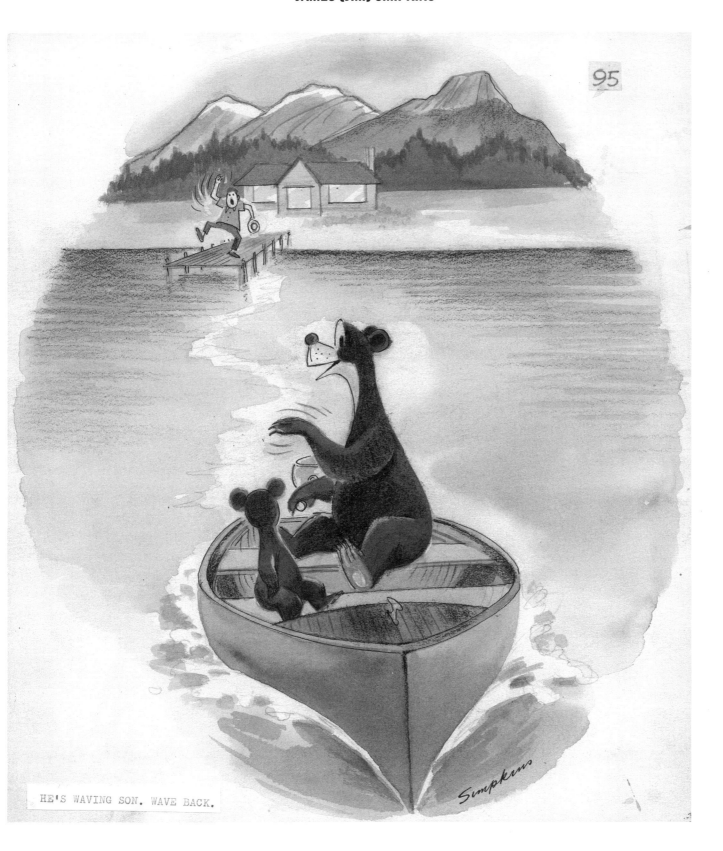

HE'S WAVING SON. WAVE BACK.

James (Jim) Simpkins
HE'S WAVING SON. WAVE BACK, 1950–68
Library and Archives Canada

Doug Wright

Nipper and the Cat and Mouse, 1973

Library and Archives Canada

DOUG WRIGHT

"Harold, don't be such a pigslow down so Mother can enjoy the view!"

THE FUTURE

PEGGY BURNS

IN a January 2019 interview in the *Los Angeles Review of Books*, Julie Doucet, one of Canada's foremost contemporary cartoonists, is asked about the differences between how her work is received in France, Canada, and the United States. "I'm French-speaking, but first of all I'm North American," she says, and then explains how her work has always seemed out of place within the conventional norms of comics in France. "They don't know what to do with me," Doucet states matter-of-factly.

In North America, we knew exactly what to do with her. Her cartooning skill was immediately celebrated and within a short period of time she was considered one of the greatest talents to ever come out of North America, let alone Canada. Doucet is rightfully heralded as a comics visionary. But thirty years ago, she was an art school grad making comics for her friends. Her soon-to-be publisher, Chris Oliveros, was a second-generation immigrant from suburban Montreal looking to make something bigger than the everybody-who-submits-gets-in anthologies floating around at the time. And so Drawn & Quarterly was founded in 1990, and *Dirty Plotte* found its way into comic shops around the world.

Many people may not realize that Doucet was not, in fact, an outlier in Canada. In the 1980s, the country was already home to progressive, contemporary cartoonists. In 1975 Katherine Collins (then known as Arn Saba) began producing *Neil the Horse*, a nostalgic mash-up of MGM musicals, Disney cartoon style, and *Katy Keene* glamour—a comic that was its own trend. Sylvie Rancourt, an irrepressible Québécois exotic dancer, turned her restless creativity into a searching memoir called *Melody* that is both harrowing and heartwarming. Rancourt initially printed her comics herself and sold them to the customers at the same clubs where she danced. David Boswell's surreal comedy—*Reid Fleming, World's Toughest Milkman*, featuring a swaggering iconoclast—got its start in the late 1970s but blossomed in the 1980s. Henriette Valium's anxious punk-influenced scrawls featuring a laundry list of repugnance and anti-everything were starting to coalesce into dense pages that rewarded a patient eye and would later surface in *Primitive Crétin!* in the early 1990s.

Chester Brown and Seth, superhero comics hopefuls who became fast friends, ditched their particular mainstream ambitions and set out on radically different careers—Brown as a laugh-out-loud surrealist turned micro-memoirist and historian, and Seth as a 1940s *New Yorker*-style aesthete who focused on character studies of foundering Canadian men. Both forged styles that completely made sense to comics classicists but rejected nearly all of the classic approaches to comic book making.

Carel Moiseiwitsch's punk feminism, David Collier's personal digressive journalism, Maurice Vellekoop's colour-soaked mid-century stylism, and Fiona Smyth's radical street art ugly-cutism looked like nothing else happening in the North American mainstream or underground comics scene. While certainly none of these styles were forged in a vacuum, neither were they in any danger of being crushed by the comics culture at large.

All of these cartoonists (and many others) were making deeply idiosyncratic personal comics within a system that did not exactly support that work. And all these artists were creating work before Chris Oliveros started to recruit cartoonists and illustrators for his anthology, which later grew into a venerated publishing house specializing in com-

ics and graphic novels. In the thirty years that Drawn & Quarterly has existed with its younger counterparts—La Pastèque and Pow Pow in Montreal, Koyama in Toronto, and Conundrum in Wolfville, Nova Scotia—Canada has quietly stepped to the forefront of the contemporary comics medium, and we do it in two languages.

While it is not entirely true that the origins of Canada's dominance in comics lie in Ontario and Quebec, Toronto and Montreal did serve as creative hubs for the contemporary comics movement in Canada during the early decades, with cartoonists popping up in a number of places across the country. Marc Bell, from London, Ontario, began bouncing around Canada, picking up the detritus of post-industrial Canadian culture. He combined a loopy anything-goes kitchen-sink big-foot approach while finding the heart in his characters' relationships in his early magnum opus *Shrimpy and Paul and Friends*. Geneviève Castrée, originally from Loretteville (now part of Quebec City), combined the technical skill of early Maurice Sendak and late Julie Doucet into a style that was both ribald and deeply emotional. Both artists wore their influences on their sleeves but took their art in directions their predecessors would never have dreamed of.

In the twenty-first century, Canadian comics started to spread outward from Toronto and Montreal. As well, the two biggest cities started translating their comics into the country's two official languages. Montreal's Michel Rabagliati's charming comics of quotidian Québécois life were translated into English; Quebec's Guy Delisle took his viewpoint internationally and became Canada's foremost non-fiction cartoonist with a series of travel

memoirs, beginning with *Pyongyang: A Journey in North Korea* (2005); Cape Breton's Kate Beaton deliciously won over the entire continent with humour about what it means to be Canadian; Jillian Tamaki took top honours in both Canada and the US (along with her cousin Mariko Tamaki) for perfectly constructed tales of adolescent ennui; Ho Che Anderson, named for Ho Chi Minh *and* Che Guevara, created one of the first modern comic biographies (*King*, about Martin Luther King Jr., completed in 2002), and Chester Brown published the groundbreaking *Louis Riel* (2003); Michael Nicoll Yahgulanaas, from Haida Gwaii,

Fig 6. Julie Doucet, *Vol/Robbery*, 1989

developed Haida manga by blending Indigenous imagery and storytelling with Japanese manga traditions in *Red* (2009).

Perhaps Canada lacks the overriding influence of national heroes that fledgling scenes can't look past and mature scenes get locked into—and this is partly what has contributed to such a healthy, self-confident country of comics creators. The US has Jack Kirby's sculptural dynamism and Robert Crumb's bristling, rubbery anger. Comics from France and Belgium are enthralled by *Tintin*'s architectural minimalism and André Franquin's big-nose slapstick. Canada has ties to all of this but isn't beholden to any of it.

While the US and France are heralded as the inventors of modern comics, no other country has produced such a consistently diverse body of work as Canada, where the contemporary comics output has never been enslaved by current trends. Our comics creators have always operated within the larger North American system while being wholly separate. It's part of the Canadian character.

So what is the future of Canadian comics? Honestly, I don't think it looks radically different than the past. Canada has quietly led on the international scene and continues to today. It's cliché, but true. Younger artists like Jillian Tamaki and Michael DeForge have set the standards that many even younger comics makers use to approach their chosen medium. Tamaki has her feet firmly planted in the worlds of young adult and adult comics—she employs both old-fashioned power drawing with an innate sense of body language or loose gestural wild experimentalism as she sees fit. DeForge has virtually created a whole new method of comics storytelling with his narrative-drive and visually ornate flattening of form. Both possess styles so strong that they practically destroy any other path to comics storytelling. We ask ourselves, "How was this done before?"

Canadian comics will continue to grow out of and diversify from Toronto and Montreal, continue to reflect on their own identities in order to fragment and morph the national identity, continue to push the form's boundaries and—most importantly—continue to operate free from fashion. In fact, we see all of this happening right now.

The internet, and social media specifically, helped to expand opportunities outside the cultural centres. We're well into a second generation of cartoonists who have found their communities online. A young woman from Cape Breton working in the isolation of the Alberta oil sands drew her first comics and with the help of a tech-savvy friend put those comics online. Her wit spread quickly, embraced by high school smart alecks and Ivy League literature profs alike—something that would have been impossible in previous decades when the only way to find work like Kate Beaton's *Hark! A Vagrant* was if one was lucky enough to live in a city with a comic shop that might be willing to stock a mini-comic filled with jokes about F. Scott Fitzgerald's *The Great Gatsby*. Instead, her comics or links to them were emailed around, passed from person to person, until *Hark! A Vagrant* became enough of a sensation that it made the *New York Times* bestseller list. Beaton is now at work on a memoir of her time in the oil sands and the relationship between the Alberta oil economy and Nova Scotia.

Connor Willumsen, from Calgary, began his career working on mainstream comics, but he quickly turned his back on them and began creating some of the most narratively challenging work being made by anyone in any country. Sylvia Nickerson's work is tied strongly to Hamilton, where she lives, works and raises a family as her comics lead us through a post-industrial city that in many ways defines modern North America. Her motherhood is central to her art. The cartoonist known as GG lives in small-town Alberta. Her stories are minimalist and influenced by French New Wave, narratively spare and emotionally charged. Patrick Kyle, from Toronto, combines a big-foot slapstick approach indebted to his fellow Ontarian Marc Bell with a creeping paranoia that is all his own. Julie Delporte left an indifferent France and moved to Montreal. She found

a rich, feminist Canadian comics culture that nurtured her voice—something that may not have happened had she not had access to both French and English scenes as well as a diverse bookstore culture and affordable housing. Aminder Dhaliwal attended Sheridan, her local college in Brampton, Ontario, which just happens to be the leading animation school in North America. She entered the US animation industry and after sharpening her storytelling chops there, launched an Instagram comic that eventually drew 100,000 followers. Hartley Lin, who lives in the

How does one vast country create so many individualist cartoonists? Living in a socialist democracy certainly helps: there is little stress around health care or the quality of public education, for example. Government support for publishing and the arts plays a key role. The Canada Council for the Arts awards grants for graphic novels that allow cartoonists to get monetary support by being cartoonists instead of trying to sneak support as visual artists or fiction writers. Canada Council also supports independent publishers. In Quebec, independent bookstores are supported and recognized

PERHAPS CANADA LACKS THE OVERRIDING INFLUENCE OF NATIONAL HEROES THAT FLEDGLING SCENES CAN'T LOOK PAST AND MATURE SCENES GET LOCKED INTO—AND THIS IS PARTLY WHAT HAS CONTRIBUTED TO SUCH A HEALTHY, SELF-CONFIDENT COUNTRY OF COMICS CREATORS.

Saint-Lazare suburb of Montreal, garnered much acclaim in 2018 for his book *Young Frances*. Isabelle Arsenault is the Governor General Award-winning illustrator of *Jane, the Fox, and Me*. Lorina Mapa of Sherbrooke, Quebec, penned a memoir of growing up in the Philippines in the 1980s: *Duran Duran, Imelda Marcos, and Me*. Jessica Campbell is working on a graphic novel inspired by her religious upbringing on Vancouver Island. Walter Kaheró:ton Scott is busy on his third installment of the bestselling and very funny *Wendy* series. Ness Lee and Vivek Shraya have created the book *Death Threat*, based on the actual death threats Shraya started to receive in 2017 shortly after coming out as trans.

as an important part of contemporary culture. Many provinces offer both artist and publishing grants. To be protected by a government and citizenry that innately understand the value of creative endeavours to the health of a nation is key to our success. This isn't to paint Canada as some sort of utopia where every doodle is met with a wheelbarrow of cash, but when a cartoonist decides they want to make comics, the future isn't a black hole.

As a publisher, I would be remiss if I did not discuss the business of comics. One can definitely not overstate the crucial role that the federal and provincial governments play in supporting Drawn & Quarterly but also Koyama Press, Conundrum Press, Éditions de La Pastèque and Les

Éditions Pow Pow. Each of these publishers stands out as being exemplary in making author support their primary mission. All Canadian comic book publishers export their own books. Drawn & Quarterly, Koyama and Conundrum sell into the US and the UK. La Pastèque and Pow Pow sell into France.

English comic book companies operate in a North American market, dating back to the early days of comic book distribution before comics were sold in bookstores. This is in contrast to prose publishing in Canada, which by and large operates in the two traditionally separate US and Canadian book markets, where what rights you hold and whether you are able to distribute in the United States differ from title to title. The ability to sell our own books in markets outside Canada seems like a fine point, but this is actually what allows us to have international influence and gives us the financial command to compete with companies · outside Canada. Most of the time, English comic book companies hold World English rights and distribute and sell their books in the UK as well as in North America. Similarly, the French comic book publishers hold World French rights and sell into France. By exporting our own comics culture and being the primary English publisher for cartoonists around the world, Canada will become an even stronger comics creator. Who better to export our own culture than us?

We need to mentor future publishers to continue Canada's comics legacy. We need to train these companies in succession planning. We need to push these companies to be as artist friendly as possible. They already strike an ethical and creative contrast to the many faceless multinational publishing houses that fail to nurture the artist and therefore the medium. With very few exceptions, multinationals are solely commercial ventures seeking to round off the edges and make nice, safe, "educational" work for the uncritical masses. They're not interested in creating a community, advocating for artist grants, supporting local shops, or finding idiosyncratic voices so much as they are interested in maintaining the bottom line.

It's not just about Canadian publishers and cartoonists. We have ship Canadian store, the Beguiling, proudly LGBTQ+. Supporting our local comic book shops and supporting new owners who in turn support their local cartoonists will help to ensure that Canada's comics retain their distinctive individuality.

With all of these cartoonists and projects that exist now or in the

IT'S NOT JUST ABOUT CANADIAN PUBLISHERS AND CARTOONISTS. WE HAVE MAGNIFICENT LIBRARY SYSTEMS THAT LOVE GRAPHIC NOVELS. WE HAVE UNIVERSITIES THAT ADOPT OUR GRAPHIC NOVELS IN THEIR CLASSROOMS AND TEACH A NEW GENERATION OF CARTOONISTS AND TRAIN A GENERATION OF READERS IN ALL DISCIPLINES.

magnificent library systems that love graphic novels. We have universities that adopt our graphic novels in their classrooms and teach a new generation of cartoonists and train a generation of readers in all disciplines. We now have three festivals—in Toronto, Vancouver and Montreal—that showcase the best of our culture and medium. Perhaps the future will bring a festival, residency or conference to Yellowknife or St. John's. This very exhibit at the Art Gallery of Hamilton shows that institutions outside of our cultural centres are exploring their own city's comics, from the historical—Doug Wright and the political cartoonist Blaine—to the now, including Joe Ollmann and Meredith W. Park and others.

We have independent comic book shops in all of our main cities from the West Coast to the Maritimes. Many of them are owned and/or run by women, with our flag-near future that show the vast richness and diversity of Canada, and the institutional infrastructure to support independent cartoonists and businesses, how do we move forward in Canadian contemporary comics? We hold ourselves accountable. We recognize that we can still do better. We admit that these processes still benefit people who know how the system works. We expand and look outward. We teach. We mentor. We publish. We introduce. We speak. We show. We befriend. We support. We celebrate.

We read. ◗

ARTISTS

SAMI ALWANI is a cartoonist and illustrator based in Toronto. His work has appeared in the anthology *Best American Comics*, *Vice* and in *Broken Pencil* magazine. He also received a Doug Wright Award in 2017 honouring the year's best Canadian comics for his story *The Dead Father*. Through the lens of heavily mytholo- gized autobiography, his work examines themes of sexual identity, mental illness, socialism and the absurd. Alwani gradu- ated from the Maryland Institute College of Art in 2015. He is currently working on two projects for Fantagraphics Books and Conundrum Press.

HO CHE ANDERSON was born in London, England, and was named after the Vietnamese and Cuban revolutionaries Ho Chi Minh and Che Guevara. Anderson is the author of numerous graphic nov- els, including *King*, a biography of Martin Luther King Jr., and the science fiction action-adventure *Godhead*. He studied film production at the Toronto Film School and Sheridan College. Anderson previously worked as a *Toronto Star* reporter and as an International Alliance of Theatrical Stage Employees camera assistant, and he has shot and directed

short films. Anderson is currently in pre-production on his first feature film, *Le Corbeau*. He is also frantically develop- ing television content for Time Warner and about to start writing *The Resurrectionists*, a supernatural graphic novel for Abrams Books.

KATE BEATON is an Eisner Award-winning, *New York Times* bestselling cartoonist and picture book author whose work has appeared in the *Globe and Mail*, the *Guardian*, the *New Yorker*, *Time* maga- zine, and the *Walrus*. Her next book is a graphic memoir of working in the Alberta oil fields from 2005 to 2008, to be pub- lished by Drawn & Quarterly. She lives in Nova Scotia.

MARC BELL is the author of *Worn Tuff Elbow*, *Stroppy*, *Hot Potatoe [sic]* and *Shrimpy and Paul and Friends* and is a co-founder of the All Star Schnauzer Band. His comics have appeared in many Canadian weeklies, *Vice*, and *LA Weekly*. He has edited several books, in- cluding Mark Connery's *Rudy* (2D Cloud) and *Nog a Dod: Prehistoric Canadian Psychedooolia* (PictureBox/Conundrum). Bell's work was recently included in

Words in Pictures at Adam Baumgold Gallery (New York) and *Exhibition Kramers Ergot* at Formula Bula (Paris).

BLAINE was the name used by po- litical cartoonist Blaine MacDonald (1937–2012). Blaine was born in Glace Bay, Nova Scotia, and later moved to Hamilton, where his work was published in the *Hamilton Spectator*. He received the National Cartoonist Society Editorial Cartoon Award in 1969.

SIMON BOSSÉ made a name for himself in the Montreal zine scene in the early 1990s and has been screen-printing books and posters under the name Mille Putois ever since. In 2014, Conundrum Press published a collection of his French books in English under the title *Loiterers*. Bossé now lives in the small town of Brigham, Quebec, and works as art director for the Dunham Brewery.

DAVID BOSWELL was born in London, Ontario, in 1953. He started publishing comics in 1977 with *Heart Break Comics*, and in 1978 began the weekly strip *Reid Fleming, World's Toughest Milkman*. The first *Reid Fleming* book was published in 1980, and he has just completed the tenth book in the series. Boswell currently lives in Vancouver with his wife of over forty years.

CHESTER BROWN was born in 1960 in Montreal and grew up in a nearby suburb. He moved to Toronto in 1979 and, in 1983, began self-publishing his comic strips. A comic book publisher took over putting out Brown's work and released his first graphic novel in 1989. In 2003, Brown's most well-known graphic novel was published: *Louis Riel*, about the nineteenth-century Métis leader. Brown's next graphic novel was *Paying for It*, a memoir about his experiences with sex workers. His most recent graphic novel, *Mary Wept Over the Feet of Jesus* (2016), interprets prostitution-related biblical stories.

NINA BUNJEVAC was born in Canada but spent her formative years in Yugoslavia, where she began her art education. She returned to Canada at the onset of the Yugoslav Wars of the 1990s, and continued her education in graphic design at the Art Centre at Central Technical School in Toronto, and subsequently graduated from OCAD in Drawing and Painting. Her first book, *Heartless* (2012, Conundrum Press), won the Doug Wright Award in the Nipper category for the best debut. Her second book, *Fatherland* (2014, Jonathan Cape), garnered international acclaim, appearing on the *New York Times* bestseller list and receiving the Doug Wright Award in the Best Book category. *Fatherland* was also shortlisted for the PACA region Literary Award in France, where she now lives. Her latest book, *Bezimena*, was published by Ici Même Editions in 2018.

JESSICA CAMPBELL is a Canadian artist currently based in Chicago, working in comics, fibres, painting and drawing. She is the author of *XTC69* and *Hot or Not: 20th-Century Male Artists*, both published by Koyama Press. She has had solo exhibitions at the Museum of Contemporary Art (Chicago);

Field Projects (New York); Western Exhibitions (Chicago); Galerie Laroche/ Joncas (Montreal); and has participated in group exhibitions throughout Canada and the US.

GENEVIÈVE CASTRÉE (1981–2016) was born in Quebec. Swept away by comics, she wanted to be a cartoonist from the age of nine. Castrée felt the urge to publish her mini-comics early, appearing in the Montreal underground scene while she was still a teenager. In addition to her books, Castrée had a number of exhibitions in Canada, the United States, Europe, Australia and Japan. Castrée spent her adult life in the Pacific Northwest with her husband and daughter, where she drew, made small sculptures out of porcelain, and played music under the name Ô PAON.

MARTA CHUDOLINSKA is a multidisciplinary artist based in Toronto who makes comics, artist books and other publications using woodcut and linocut prints, papercuts, and a variety of drawing materials. Her first wordless graphic novel, *Back + Forth: A Novel in 90 Linocuts*, was published in 2009 by Porcupine's Quill. Her comics incorporate personal narratives, fantastical stories and the handmade. Her papercut comic, *Babcia*, is a historical memoir that aims to rebuild her connection to her late grandmother, cut short by immigration and illness; it has been serialized in *Broken Pencil* magazine since 2013.

DAVID COLLIER was born in 1963 in Windsor, Ontario, to immigrant parents from England, who wished he studied as hard at school as he did with old comics. He turned his back on the old country, mastering Nordic skiing and travelling as far north as Resolute, Nunavut, with the Canadian military. His Canada-centric comics have been featured in *Best American Comics* and Yale University Press anthologies. He spoke about his most recent book, *Morton: A Cross-Country Rail Journey*, at the Singapore Writers Festival in 2018, where he tried to explain a big country to people living in a small one.

KATHERINE COLLINS, creator of *Neil the Horse*, was born in Vancouver in 1947, but everyone thought she was Arnold Saba Jr., aka Arn Saba, until 1993. She was named to Giants of the North: The Canadian Cartoonist Hall of Fame in 2013 and in 2017. Collins has indulged in many arts: songwriting, playwriting, children's theatre, filmmaking, magazine journalism and radio programming. Cartooning finally prevailed when she debuted *Neil the Horse*, first in newspapers in 1975, and in comic books in 1982. A smattering of sparse but fervent acclaim followed. But transsexualism was not socially acceptable. Katherine was deemed unpublishable until 2013, and again 2017, when she was remembered and celebrated by the Canadian comics community. An anthology was published in 2017. More *Neil* might be coming, if Katherine lives a bit longer.

MICHAEL DEFORGE was born in 1987 and works as a cartoonist in Toronto. His books include *Leaving Richard's Valley*, *Brat*, *A Western World*, *Sticks Angelica, Folk Hero*, *Dressing* and *Ant Colony*.

JULIE DELPORTE was born in Saint-Malo, France, in 1983, and currently lives in Montreal. *This Woman's Work* is her third graphic novel, after *Journal* (2014) and *Everywhere Antennas* (2015). She holds a degree in Cinema Studies and was a fellow at the Center for Cartoon Studies in White River Junction, Vermont. When she's not working on comics, she makes ceramics, writes poetry and essays, gives art workshops, and works on risograph and silkscreen projects.

AMINDER DHALIWAL is a native of Brampton, Ontario, and received a Bachelor of Animation from Sheridan College. She now lives in Los Angeles, where she is a director at Disney Television Animation. Previously, she worked as a Storyboard Director at Cartoon Network and a Storyboard Director on the Nickelodeon show *Sanjay and Craig*. *Woman World* has appeared biweekly on Instagram since March 2017, garnering over 140,000 followers and a nomination for an Ignatz Award for Outstanding Online Comic. *Woman World* was published as a book by Drawn & Quarterly and released at Comic Con in July 2017.

JULIE DOUCET was born in 1965 in Montreal. After completing a certificate in printmaking at Université du Québec à Montréal, she focused on creating autobiographical comics, which have been translated into several languages, including Japanese. Despite her success, Doucet abandoned the medium in 1999 and went back to printmaking. She became a member of the Atelier Graff and has since produced artist's books while continuing to work with words and images. In 2009, she ventured into animated film, again using words and images. A retrospective exhibition of her comic art work, drawings, collaged

poetry, animation films and artist's books took place in 2017 at the Fumetto International Comics Festival in Lucerne.

PASCAL GIRARD was born in Jonquière, Quebec, in 1981. He has been making comics since 2005 and is the author of *Nicolas*, *Bigfoot* (winner of the 2011 Doug Wright Award for Best Book), *Reunion* and *Petty Theft*, all published by Drawn & Quarterly. He now lives in Montreal with his family. Since 2014, he is a part-time cartoonist and part-time social worker with the McGill University Health Centre's Movement Disorder Clinic.

GORD HILL is an Indigenous writer, artist and activist of the Kwakwaka'wakw nation. He is the author and illustrator of *The 500 Years of Resistance Comic Book*, *The Anti-Capitalist Resistance Comic Book*, and *The Antifa Comic Book* (all three published by Arsenal Pulp Press), as well as the author of the book *500 Years of Indigenous Resistance*, published by AK Press of Oakland, California. His art and writings have also been published in numerous periodicals, including *Briarpatch*, *Canadian*

Dimension, *Redwire*, *Red Rising*, the *Dominion*, *Recherches Amérindiennes au Québec*, *Intotemak*, *Seattle Weekly*, and *Broken Pencil*.

JESSE JACOBS is known for his precise and detailed line work in combination with bold and simple colour palettes. His comics contain an affiliation with psychedelia, spirituality and alternative realities. His books—*By This Shall You Know Him* (Koyama Press, 2012), *Safari Honeymoon* (Koyama Press, 2014), and *Crawl Space* (Koyama Press, 2017)—have been translated into several languages, with *Crawl Space* winning the Doug Wright Award for Best Book. His stories have been selected for the 2012, 2013, and 2015 editions of *Best American Comics*. He currently lives in London, Ontario, with his partner, Jinette, and his dog, Desmond.

PATRICK KYLE is a commercial illustrator from Toronto. Since graduating from the Ontario College of Art and Design in 2009 he has created illustrations for the *New York Times*, *Lucky Peach*, *Bloomberg*

Businessweek, *MIT Technology Review*, the *Baffler*, *Transworld Skateboarding* and many others. He is the author of the graphic novels *Black Mass* (Mother Books, 2012), *Distance Mover* (Koyama Press, 2014), *Don't Come in Here* (Koyama Press, 2016), *Everywhere Disappeared* (Koyama Press, 2017) and *Roaming Foliage* (Koyama Press, 2018). He is an active member of Toronto's independent comic book and zine community and has contributed to organizing the small press portion of the Toronto Comic Arts Festival since 2009. He became a co-organizer of the annual small press exhibition Zine Dream in 2015.

GINETTE LAPALME is a visual artist working in Toronto, Canada. Since graduating from the Ontario College of Art and Design in 2009 she has created illustrations and animations for the *New York Times*, the *Walrus*, *Flare* magazine and Hardly Art Records, among others. Lapalme is a founding member of Woweezonk, a comic trio who have produced four self-titled comic anthologies and have been curating a space at the Toronto Comic Arts Festival since 2009. Her art book *Confetti* was published by Koyama Press (2015), and she has had comics published in many other anthologies.

NESS LEE is an illustrator and artist based in Toronto. She graduated from OCAD University with a Bachelor of Design in Illustration and has exhibited her works at galleries in Toronto, New York, Los Angeles, New Orleans, Boston and Tokyo. She continues to explore notions of intimacy and self-love in her practice using a wide range of mediums such as ceramics, drawing, painting and mixed media sculpture.

HARTLEY LIN is a Montreal-based cartoonist and former low-level government bureaucrat who used to work under the pen name Ethan Rilly. His ongoing comic book *Pope Hats* has received Doug Wright, Ignatz and Joe Shuster awards, and he contributes to magazines like *Taddle Creek* and the *New Yorker*. He began using his real name in 2018 with the release of the graphic novel *Young Frances*. He is a dog person.

GRAEME MACKAY grew up in Dundas, Ontario, attending classes at Dundana Public School, Parkside High School, and the Dundas Valley School of Art. He attended the University of Ottawa, where he majored in History and Political Science. In 1997, he was hired as full-time editorial cartoonist at the *Hamilton Spectator*, producing five cartoons every week. He has been president of the Association of Canadian Editorial Cartoonists and has received excellence citations from past UN Lurie Award competitions. Graeme has lived in Hamilton, Ottawa, Toronto and London, UK. He now lives in Hamilton, with his wife, Wendi, and their daughters, Gillian and Jacqueline.

BILLY MAVREAS is a Montreal-based multi-disciplinary artist and writer working at the intersection of comics and visual poetry. He also produces book works, installation, painting and sound works. As a small press and creativity advocate he leads workshops and speaks on creative process and the accessibility of inspiration. Since 2000 he has operated Monastiraki, an art space in the Mile End neighbourhood, hosting events, curating exhibits and showcasing his work and the work of dozens of other artists. His

graphic novels include *The Overlords of Glee* (Conundrum Press, 2001), *Inside Outside Overlap* (Timeless Books, 2008) and *Tibonom* (Éditions Trip, 2013). He is currently working on three new book-length projects.

CAREL MOISEIWITSCH was born in London during the Second World War, and her first career choice was to be a monk and make illustrated manuscripts on the island of Iona. She has lived in Vancouver since the early 1970s. "I have scratched a living doing this and that in order to be able to draw. That has been my lifelong obsession. I have drawn in many formats. Always trying to find a way to undermine people's unexamined ideas, whether visual or political. Comix in the 80s was an excellent way to do this. Will they still challenge thirty years later? Sadly, they probably will!"

SYLVIA NICKERSON is a comics artist, writer and illustrator who lives in Hamilton. Her focus is storytelling in community arts and writing comics examining parenthood, gender, social class and religion. Her illustrations have appeared in major newspapers, including the *Globe and Mail*, *National Post*, *Boston Globe* and *Washington Post*, and her comics have been nominated for a Doug Wright Award.

DIANE OBOMSAWIN spent the first twenty years of her life in France. After studying graphic design, she returned to Canada and turned her attention to painting, comics and animation. *Here and There* (2006), an autobiographical film about the artist's rootless childhood, has garnered numerous awards. Over the years, Obomsawin has developed a unique style, achieving a balance between humour and seriousness, naïveté and gravitas, realism and poetry. She has published four books with L'Oie de Cravan, a publishing house that specializes in poetry, and two books with Drawn & Quarterly: her first, *Kaspar* (2007), is about the life of Kaspar Hauser, and was accompanied by a short film of the same name; her second, *On Loving Women* (2014), is about women's coming-out experiences.

SIMON ORPANA is an artist, researcher and educator whose work investigates the intersections of culture, economics and politics. His writing has appeared in numerous journals and book collections, including *Zombie Theory: A Reader* (University of Minnesota Press, 2017). He is co-author, with Rob Kristofferson, of the graphic history *Showdown!: Making Modern Unions* (Between the Lines,

2016). He is currently a postdoctoral fellow in the Department of English and Film Studies at the University of Alberta, working on a book-length graphic essay that examines the cultural and political barriers to imagining a world less dependent on fossil fuels.

MEREDITH W. PARK is a cartoonist from Hamilton, Ontario. She was raised in the US and returned to Canada for her education and artistic development, with support from the Eucharist Church Arts Residency of 2015. She has been published in *Geez* magazine, *Applied Arts* and *SubTerrain*, among others. Her work explores the bonds of family, faith, mental illness, bicycle repair and starting from scratch.

COLE PAULS is a Tahltan comic artist, illustrator and printmaker hailing from Haines Junction, Yukon, with a BFA in Illustration from Emily Carr University. Residing in Vancouver, Pauls focuses on his two comic series: *Pizza Punks*, a self-contained comic strip about punks eating pizza; and *Dakwäkãda Warriors*, which is about two Southern Tutchone Earth Protectors saving the earth from evil pioneers and cyborg sasquatches using language revitalization. In 2017,

Pauls won *Broken Pencil*'s Best Comic and Zine of the Year Award for *Dakwäkãda Warriors II*.

GORD PULLAR is an artist based in Hamilton.

MICHEL RABAGLIATI was born in Montreal in 1961. Following in his father's footsteps, he studied typography and graphic design, later changing course to focus on editorial and advertising illustration. In 1998, to kill time between two illustration orders, he wrote and drew his first two stories in comics: "Paul à la campagne" and "Paul apprenti typographe." Now, with nine volumes of Paul's adventures published by Éditions de la Pastèque, Rabagliati has become a key figure in Quebec comics. In 2007, he was awarded a special mention for his work by the Prix des libraires du Québec. He was the first Canadian to win an award at the Angoulême International Comics Festival (Prix du public 2010 for *Paul à Québec*) in France. He was awarded Compagnon des arts et des lettres du Québec in 2017.

Wendy was selected for the 2016 edition of *Best American Comics* (Houghton Mifflin Harcourt). In 2019, Walter will be an artist-in-residence for six months at the International Studio & Curatorial Program (ISCP) in Brooklyn, New York.

R.A. ROSEN was born and raised in Montreal. She completed an internship with Drawn & Quarterly at the age of seventeen, and then worked in their production department for many years where she learned everything she needed to know about comics and design. Following the completion of her BFA at Concordia University in 2010, she moved to France for a brief but transformative stint in Marseille at the screen-printing facilities of the transgressive art-house publisher Le Dernier Cri, where she met her future partner, Quentin Pillot. Together they founded L'APPÂT, a print studio and small press based in Brussels. Her first graphic novel, *Flem*, was created to fulfill the requirements of a master's degree in Graphic Narrative at LUCA School of Arts in Brussels. It was published in 2018 by Conundrum Press.

SETH is the cartoonist behind the long-running comic book series *Palookaville*. His books include *Wimbledon Green*, *George Sprott*, and *It's a Good Life, If You Don't Weaken*. He is the designer for *The Complete Peanuts*, *The Portable Dorothy Parker*, *The Collected Doug Wright* and *The New World: Comics from Mauretania*. He is the subject of the recent award-winning NFB documentary *Seth's Dominion* and was the winner, in 2011, of the prestigious Harbourfront Festival Prize. After twenty years of serialization, his graphic novel *Clyde Fans* was released as a deluxe edition in 2019.

FIONA SMYTH is a feminist painter, illustrator, educator and cartoonist based in Toronto. In 2012, she collaborated with writer and sex educator Cory Silverberg on the Kickstarter-funded picture book *What Makes a Baby*, re-released by Seven Stories Press in 2013. An award-winning second book, *Sex Is a Funny Word*, followed in 2015. Fiona collaborated with writer Mariko Tamaki for *Secret Loves of Geek Girls*, and with cartoonist Ron Rege Jr. on *Perish Plains Volume 4* for Perish Publishing. Her comics can be found in *Resist #1* and *2*, edited by Françoise Mouly and Nadja Spiegelman. In 2018, thirty years of Smyth's comics were published in *Somnambulance* by Koyama Press. Smyth teaches illustration and cartooning at OCAD University and the Art Gallery of Ontario.

WALTER SCOTT is an interdisciplinary artist working across comics, drawing, video, performance and sculpture. His comic series *Wendy* chronicles the continuing misadventures of a young artist in a satirical version of the contemporary art world. *Wendy* has been published in two volumes by Koyama Press, and has been featured in *Canadian Art*, *Art in America*, and published online by the *New Yorker*.

JAMES (JIM) SIMPKINS (1910–2004) was a Winnipeg-born Canadian cartoonist and artist. He was one of the original artists for the National Film Board, where he worked full-time for sixteen years. His cartoon character Jasper the Bear was a regular feature in *Maclean's* from 1948 to 1968, and in syndicated newspapers from 1968 until he retired in 1972. Jasper the Bear remains the mascot of Jasper National Park.

JILLIAN TAMAKI is an illustrator and comics artist living in Toronto. A professional artist since 2003, she has worked for publications around the world and taught extensively in New York at the undergraduate and graduate level. She is the co-creator, with her cousin Mariko Tamaki, of *Skim* (2008) and *This One Summer* (2014), which won many awards including the Caldecott and the Printz Honor awards, the Ignatz and the Eisner. Her first picture book, *They Say Blue*, which explores our perception and experience of the natural world, was released in 2018.

MAURICE VELLEKOOP is an award-winning Toronto illustrator whose work has appeared in magazines, advertising, books and posters in North America and Europe for over thirty years. Maurice has a long history in comics, beginning with zines and solo art shows in the 1980s. Drawn & Quarterly published his work in its eponymous anthology for many years. These were collected in a 1997 monograph titled *Vellevision*. Other publishers include Green Candy Press and Koyama Press. Since 2013, Maurice has been at work on a memoir titled *I'm So Glad We Had This Time Together*, edited by Chip Kidd, to be published by Pantheon Books.

ERIC KOSTIUK WILLIAMS is a cartoonist based in Toronto. His work explores queer culture, music, psychedelia and community resilience in the face of late capitalism. Eric's comics have been nominated for Eisner, Doug Wright and Lambda Literary Awards. He was the recipient of the 2018 Queer Press Grant for his graphic novella *Our Wretched Town Hall*. In addition to publishing his work with Koyama Press and Retrofit/Big Planet, Eric has contributed comics to several magazines, including *NOW*, *Carousel*, *Phile* and the *Believer*.

Doug Wright Award, Pingprisen Award and Ignatz Award. Recently, a collaborative narrative project between Willumsen and artist Jon Rafman appeared at the Sharjah Biennial 14.

JENN WOODALL is a comics creator and illustrator who grew up in Brampton and now lives in Toronto, Ontario. She is a recent graduate of OCAD University's Illustration program. The majority of her comic work touches on issues relating to feminism and mental illness. In 2018, she won a Doug Wright Award for her comics *Marie + Worrywart* and *Magical Beatdown*, as well as a Joe Shuster Award. Her work has been published by Silver Sprocket, Avery Hill, Hic & Hoc and Dark Horse Comics. She is currently working on a series of graphic novels.

KAT VERHOEVEN is a Canadian cartoonist from Kingston who has spent most of her adulthood in Toronto. She holds a degree in illustration from OCAD University. Verhoeven is known for her award-nominated comic *Towerkind* and her webcomic-turned-book *Meat and Bone*, as well as her anthology and zine work. Her stories centre on the idea of found families and identity, combining the hard realities of ink lines with playful gradient digital colour.

CONNOR WILLUMSEN is a Montreal-based multidisciplinary artist. He has designed and illustrated covers for the Criterion Collection and illustrated books for various publishers, while his main body of work, self-authored printed comics, has received various awards, honours, and academic scholarships, including a fellowship at the Center for Cartoon Studies. His work is published by Breakdown Press, and his first major book, *Anti-Gone* (Koyama Press, 2017), was a finalist for the LA Times Book Prize,

DOUG WRIGHT (1917–1983) was a Canadian cartoonist, best known for *Doug Wright's Family*, a weekly strip that ran in newspapers and magazines from 1949 to 1980. Wright also worked as an editorial cartoonist for the *Montreal Standard* and the *Hamilton Spectator*. Established in 2004, the Doug Wright Awards are named after him to honour excellence in Canadian cartooning.

CONTRIBUTORS

PEGGY BURNS is the publisher of the Montreal-based graphic novel house Drawn & Quarterly. In 2003, she moved from NYC, where she worked at DC Comics and *MAD* magazine, to Montreal to assist founder Chris Oliveros in expanding the company. In the sixteen years she has been at Drawn & Quarterly, she has overseen the company grow from two employees to thirty; ten books a year to thirty; and the opening of two brick and mortar flagship bookstores in Montreal.

JOE OLLMANN is a cartoonist living in Hamilton, Ontario. He is the winner of the Doug Wright Award for Best Book in 2007 and loser of the same award many other times. Author of seven books, *Chewing on Tinfoil* (Insomniac, 2001), *The Big Book of Wag!* (Conundrum, 2006), *This Will All End in Tears* (Insomniac, 2006, Winner of the 2007 Doug Wright Award), *MID-LIFE* (Drawn & Quarterly, 2011), *Science Fiction* (Conundrum, 2013), *Happy Stories About Well-Adjusted People* (Conundrum, 2014) and *The Abominable Mr. Seabrook* (Drawn & Quarterly, 2017), he is also a dour, teetotalling vegetarian.

ALANA TRAFICANTE is a contemporary curator, art writer and gallery director based in Toronto. She has worked with the Art Gallery of Hamilton in various capacities since 2008, most recently as Adjunct Curator, Contemporary Art, 2017–19. Traficante holds an MFA in Criticism and Curatorial Practice from OCAD University and a BA in Art History from the University of Toronto. She frequently researches, curates and writes about contemporary artists working in lens-based media and installation but also specializes in Canadian artist-run culture and has been researching indie comics since 2014. She is currently the Executive Director of Gallery 44 Centre for Contemporary Photography, a non-profit, artist-run centre in Toronto.

JEET HEER is a contributing editor at the *New Republic* who has published in a wide array of journals including the *New Yorker*, *Paris Review*, *Comics Journal* and *Virginia Quarterly Review*. He is the author of two books: *In Love with Art: Françoise Mouly's Adventures in Comics with Art Spiegelman* (2013) and *Sweet Lechery: Reviews, Essays & Profiles* (2014). With Chris Oliveros and Chris Ware, he's the co-editor of the multivolume *Walt and Skeezix* series, reprinting Frank King's classic comic strip *Gasoline Alley*. He is also the co-editor of three widely used textbooks on comics history and criticism: *Arguing Comics: Literary Masters on a Popular Medium*, *A Comics Studies Reader* and *The Superhero Reader*. *A Comics Studies Reader* won the 2010 Dave Rollins Award. He has contributed to more than thirty books.

LIST OF WORKS

All works courtesy of the artists unless otherwise noted, and are excerpts from larger publications in most cases.
Dimensions in centimetres, height before width.

SAMI ALWANI
Excerpt from *Man Bites Dog*, 2018
ink on paper
35.56 x 27.94 cm

Man Bites Dog (colour overlay), 2018
gouache on paper
27.94 x 21.59 cm

Excerpt from *The Idiot* (pages 1–5), 2017
ink on paper
45 x 36.2 cm, each

HO CHE ANDERSON
Excerpt from *Summer of the Gun*, 2008
acrylic, coloured pencil, pastel, pen and ink,
graphite on gessoed illustration board
51.44 x 38.1 cm

"St. Denis, Montreal, 1990," from *King: A
Comics Biography*, 1993
line art and colour separations (4 pages)
line art: pen and ink, acrylic over blue lines
printed on Crescent illustration board
49 x 33.02 cm

Excerpts from *King: A Comics Biography*
(pages 23, 92–93), 1992
pen and ink on paper
page 23: 49.21 x 33.02 cm; pages 92–93:
43.18 x 27.94 cm, each

KATE BEATON
Chopin and Liszt (2 pages), March 17, 2011
ink on paper
30.48 x 22.86 cm, each

Caesar (2 pages), April 5, 2011
ink on paper
30.48 x 22.86 cm (varying orientation), each

Gatsby (3 pages), April 20, 2011
ink on paper
30.48 x 22.86 cm, each

Lois Lane (2 pages), April 21, 2011
ink on paper
30.48 x 22.86 cm, each

Brown Recluse Spider Man (1 page), June 1,
2011
ink on paper
30.48 x 22.86 cm

Wuthering Heights (4 pages), September 5,
2011
ink on paper
30.48 x 22.86 cm, each

Jane Eyre (2 pages), September 27, 2011
ink on paper
30.48 x 22.86 cm, each

MARC BELL
"It Kind of Looks Like Comic Book Art..." from
The Ten-Eyed One Visits an Art Gallery, 2018
ink on paper
4.1 x 33 cm

"The Ten-Eyed One Exits..." from *The Ten-Eyed
One Visits an Art Gallery*, 2018
ink on paper
4.9 x 33 cm

"Well, More of the Same..." from *The Ten-Eyed
One Visits an Art Gallery*, 2018
ink on paper
4.9 x 33 cm

"Well, That Was Kind of a Drag..." from *The
Ten-Eyed One Visits an Art Gallery*, 2018
ink on paper
27.94 x 38.1 cm

*Destroy The House! (Replaces Pilin' Em High
Over Here)*, 2017
mixed media on paper
27.94 x 21.6 cm

*Marco Estrada Pitch'in Good/Meet Me at
the Zine Library or I Will Twitter Shame You
(Replaces Jcheeerrupp!)*, 2017
mixed media on paper
35.6 x 27.94 cm

Jcheeerrupp, 2006
mixed media on paper
27.94 x 21.59 cm
Gift of the artist, 2016

Pilin' Em High Over Here, 2004
ink on paper
27.94 x 21.59 cm
Gift of the artist, 2016

BLAINE
*The Retirement of Prime Minister Lester B.
Pearson*, 1967
brush and ink and grey crayon on commercial
board
38 x 47.6 cm
Courtesy of Library and Archives Canada,
e011314902
© Hamilton Spectator

SIMON BOSSÉ
"Le Coucou," from *Bébête* (pages 1–10), 2009
ink and watercolour on paper
26.35 x 26.35 cm, each

Excerpt from *Intestine* (pages 12–15), 2002
ink and acrylic paint on paper
26.35 x 26.35 cm, each

DAVID BOSWELL
Owl's Roost Rye, 2004
reproduction: pigment print on art paper
exhibition copy
21.59 x 27.94 cm

Owl's Roost Sign in Dundas, Ontario, 1991
reproduction pigment print from silver halide
negative
27.94 x 21.59 cm

Excerpt from *Heart Break Comics* (page 16),
1984
ink on art board
50.8 x 38.1 cm

Heart Break Comics (cover), 1984
colour reproduction
27.94 x 21.59 cm

Reid Fleming, World's Toughest Milkman #1
(front and back covers), 1980
ink on art board
38.1 x 50.8 cm

"Monday Morning," from *Reid Fleming, World's
Toughest Milkman* #1 (pages 21–23), 1980
ink on paper
35.56 x 27.3 cm

Excerpt from *Heart Break Comics* #1, 1977
ink on art board
25.4 x 20.3 cm

CHESTER BROWN
"The Prodigal Son," from *Mary Wept Over
the Feet of Jesus*: panels 157:1 (title panel) to
170:4 (final ink drawings), 2014
ink on paper and vellum
27.94 x 17.78 cm, each

Mary Wept Over the Feet of Jesus: preparatory
pencil drawings for panel 162:4 (pigs), 2014
pencil on tracing paper
4 pages, 17.78 x 21.59 cm, each
1 page, 15.24 x 21.59 cm

Excerpts from *Paying for It*, 2010:

Chapter 2, pages 27–29
(21 single sheet panels)
ink on tracing paper
12.7 x 17.78 cm, each
preparatory pencils and inks
(7 sheets, some overlaid)
12.7 x 17.78 cm, each

Chapter 2, pages 53–55
(25 single sheet panels)
ink on tracing paper
12.7 x 17.78 cm, each
preparatory pencils
12.7 x 17.78 cm, each

Chapter 28, pages 194–97
(20 single sheet panels)
ink on tracing paper
12.7 x 17.78 cm, each

Chapter 33, pages 221–23
(21 single sheet panels)
ink on tracing paper
12.7 x 17.78 cm, each
preparatory pencils
(8 sheets, some overlaid)
12.7 x 17.78 cm, each

NINA BUNJEVAC
Excerpt from *Bezimena* (1 page), 2018
ink on paper
35.56 x 27.94 cm

Excerpt from *Fatherland* (4 pages), 2014
ink on paper
35.56 x 27.94 cm, each

Excerpt from *Heartless* (1 page), 2011
ink on paper
43.18 x 27.94 cm

JESSICA CAMPBELL
Excerpts from *XTC69* (8 pages), 2017
ink on paper
6 pages, 35.56 x 27.94 cm, each
2 pages, 35.56 x 27.94 cm, each

GENEVIÈVE CASTRÉE
"Grandmother" and "Baptiste Day," from
Susceptible (pages 9, 33), 2013
India ink on Bristol board
27.59 x 21.5 cm
Courtesy of Phil Elverum

Pamplemoussi (recording), 2004
Vocals, Performer – Geneviève Castrée
Cello – Hank Pine Tepoorten
Bass, Percussion, Glockenspiel, Drums
Recorded By – Thomas Shields
Mastered By – Harris Newman
Recorded By, Mixed By – Phil Elverum
Courtesy of L'Oie de Cravan

Excerpt from *Pamplemoussi* (2 pages), 2004
India ink on Bristol board
30.48 x 30.48 cm, each
Collection of Peter Birkemoe

Pamplemoussi, 2004
vinyl record and booklet
31.5 x 31.5 cm
Courtesy of Joe Ollmann

MARTA CHUDOLINSKA
Inheritance, 2016
paper, ink, book board, glue, straw, crepe
paper, thread
81.28 x 81.28 x 15.24 cm

Babcia #6, #9, #14, #18, 2014
paper, ink, glue
22.86 x 30.48 cm, each

Back + Forth #24, #26, #29, #73, 2008
ink on paper
19.05 x 15.24 cm, each

Back + Forth woodblocks #24, #25, #29, #73,
2008
linoleum on birch plywood
13.36 x 10.8 x 2 cm, each

DAVID COLLIER
Norm's Island, 2018
pen and ink on vellum
66.04 x 27.94 cm

40 Years Ago, 2015
washable markers and water on printed board
29.21 x 21.59 cm

Downtown Sugar Shack (5 pages), 2013
pen and ink on vellum
39.37 x 27.94 cm, each

Illustration for *Wolsak and Wynne*, 2013
pen and ink on paper
21.59 x 27.94 cm

The End of Film (2 pages), 2012
pen and ink on vellum
39.37 x 27.94 cm, each

Saturday Night Jobs, 2002
colour film on acetate print
27.94 x 20.32 cm

Collier's #3 (cover) (with colour separation), 1994
pen and ink on paper; Ben Day film on acetate
47 x 36.83 cm

Danceland (illustration for the *Globe and Mail*),
1993
pen and ink on paper
16.51 x 52.07 cm

The Life of Grey Owl (pages 1–7), 1993
pen and ink on paper
45.72 x 30.38 cm, each

Apples, 1992
drawings (2 pages): pen and ink on paper
53.34 x 35.56 cm
colour separation (1 page): printer's colour
proof on film layers
27.94 x 21.59 cm
finals (2 pages): colour reproduction

Those Tenacious Teens, 1992
pen and ink on paper
45.7 x 34.3 cm

Memory Lane, 1990
pen and ink on paper
53.34 x 35.56 cm

Canada's Wonderland (3 pages), 1983
pen and ink on board
27.94 x 36.83 cm, each

Sketchbook (233 pages)
ink on paper
31.12 x 22.22 cm

KATHERINE COLLINS
"Untitled," from *Neil the Horse Comics and
Stories* #3 (page 22), 1983
India ink on Bristol board
49.53 x 36.2 cm

Neil the Horse Advertises Himself, 1982
India ink on Bristol board
20 x 36.83 cm

"Neil the Horse Meets Mr. Coffee Nerves," from
Neil the Horse Comics and Stories #3 (pages
8–9), 1981
India ink on Bristol board
38.74 x 27.94 cm, each

Neil Goes to Hell (page 4 of 4), 1977
India ink on Bristol board
50.8 x 38.1 cm
All Katherine Collins's works courtesy of The
Beguiling Books & Art

MICHAEL DeFORGE
Placeholders, 2017
digital drawings

Mascot head from *All Dogs Are Dogs*, 2015
made in collaboration with Phil Woollam
assorted synthetic fabrics, plastic and metal
frame
60 x 60 x 80 cm
Courtesy of The Beguiling Books & Art

Dogs (3 drawings), 2015
pen and brush on paper
31 x 21 cm, each
Courtesy of Annie Koyama

JULIE DELPORTE
Excerpts from *Moi aussi je voulais l'emporter*
(pages 226, 228–238), 2017
colour pencils on paper
27.94 x 21.59 cm, each

AMINDER DHALIWAL
Growing Older (2 pages), 2018
ink on paper
21.59 x 13.97 cm, each

Finals from *Growing Older* (2 pages), 2018
colour reproduction
exhibition copy

Roughs from *Woman World* (30 Post-its), 2017
graphite on Post-its adhered to pages
7.62 x 7.62 cm, each

Finals from *Woman World* (2 pages), 2017
colour reproduction
13 x 13.7 cm
exhibition copy

JULIE DOUCET
Book cover illustrations for *Dirty Plotte: The
Complete Julie Doucet* (4 pages), 2018
ink on Bristol board
23 x 30.5 cm, each

Das Jahr 2050, 2017
ink on Bristol board, collage, halftone
23 x 30.5 cm

Freehand drawings with correction fluid, 2016
Risograph
14 x 20 cm

Bang Clock Cold (16 pages), 2015
collage
25 x 19 cm, 12.5 10 cm, 12.5 x 15 cm

Notebook (hardcover with black cloth), 2014
collage, texts written with cut-out words
9.5 x 13.5 x 2 cm

J'aime, 2012
silkscreen
8.5 x 10 cm

Der Stein #6 – *Blick auf das Leben*, 2011
silkscreen
15.5 x 18 cm

Catalogue de boulons, 2010
silkscreen
7.5 x 9 cm

Der Stein #4 – *Collagen*, 2010
silkscreen
15.5 x 18 cm

Sophie Punt #16 – *It's Over Man*, 2003
box containing one booklet, silkscreen
5.5 x 9 x 2.2 cm

Sophie Punt #4 – *Collages*, 2002
box containing three booklets, silkscreen
6 x 6 x 4 cm

Sophie Punt #58 – *Käännostoimisto*, 2002
box containing one booklet, silkscreen
5.5 x 9 x 2.2 cm

Sophie Punt #2 – *Spécial astrologie*, 2001
silkscreen
11 x 14 cm

Sophie Punt #3 – *Spécial mode: costumes de
bain*, 2001
silkscreen on an Italian sports newspaper
20 x 29 cm

Dessin juin 2000 LTR, 2000
colour ink drawings (sketchbook)
14 x 19 x 3 cm

Sketchbook (grey cover and spiral binding), 2000
drawing and collage
17 x 23.5 x 1 cm

Diary #9, June 1991–February 1992
collage
9 x 12.5 x 2.5 cm

Diary #8, July 1990–May 1991
painting, collage
9 x 12.5 x 2.5 cm

A Day in Julie D.'s Life (2 pages out of 7), 1990
ink on Bristol board
19.5 x 26 cm, each

Tonight I'm Gonna Go See the Bottle Surgeons
(3 pages), 1990
ink on paper, each
27 x 35.5 cm, each

Vol/Robbery (2 pages), 1989
ink on Bristol board, each
28.5 x 36 cm, each

En manque (4 pages), 1987
ink on Bristol board, each
28.5 x 36 cm, each

First comic strip ever drawn
and its remake, 1983/2012
original: colour inks on newsprint
9 x 30.5 cm
remake: Bristol board
11.5 x 30.5 cm

drawings
Risograph
12 x 18 cm

PASCAL GIRARD
Excerpt from Untitled Book Project (page 27),
2018
ink (fountain pen), watercolour, Bristol board
27.94 x 13.56 cm

Excerpt from Untitled Book Project (pages
34–35), 2018
ink (fountain pen), watercolour, Bristol board
27.94 x 13.56 cm, each

Excerpts from Petty Theft (pages 5–6, 21–22,
41–43), 2013
ink (isograph), Bristol board
page 5: 15.24 x 22.86 cm; page 6: 14.6 x
21.59 cm

Sketchbook (including drawings of Hamilton),
ca. 2016
ink (isograph), sketchbook
8.89 x 13.97 cm

Sketchbook (including t-shirt designs),
ca. 2016
ink (isograph), sketchbook
8.89 x 13.97 cm

GORD HILL
Excerpts from The Antifa Comic Book (pages
18–21, 118–19), 2018
pen and ink
27.94 x 21.59 cm, each

"Fascist Movements in Canada: A Brief History
from the 1930s to 1990," from The Antifa
Comic Book, 2018
colour reproduction
exhibition copy

JESSE JACOBS
Crawl Space 1, 2017
silkscreen on paper, printed by Strane Dizioni, Italy
50 x 70 cm

Crawl Space 2, 2017
silkscreen on paper, printed by Strane Dizioni, Italy
50 x 70 cm

CAB postcard, 2015
silkscreen on paper, printed by Strane Dizioni, Italy
70 x 50 cm

Comics and Commerce in Canada (TCAF)
commissioned for the National Post, 2015
silkscreen on paper, printed by Strane Dizioni, Italy
70 x 50 cm

Safari Honeymoon 3, 2014
silkscreen on paper, printed by Strane Dizioni, Italy
70 x 50 cm

PATRICK KYLE
Excerpt from Everywhere Disappeared
(3 pages), 2017
ink on paper
45.72 x 30.48 cm, each

Excerpt from Black Mass (4 pages), 2009
ink on paper
35.56 x 27.94 cm, each

GINETTE LAPALME
Objects from the artist's studio
2009–19

Resins, figurines and jewelry:
Snakes in eggs on bases, 2018–19
quail egg, paint, Sculpey, resin, mixed media
(candy, glitter, styrofoam, dyes, etc.)
2.54 x 2.54 x 5 cm

Magic cats with base, 2018
resin and mixed media (glitter, confetti, dyes, etc.)
6.4 x 6.4 x 2.5 cm

Resin capsule brooches, 2016–18
resin and mixed media (Shrinky Dinks, glitter,
dyes, etc.)
Approx. 2.54 cm square

Magic cats, 2017–18
resin and mixed media (glitter, candy, dyes, etc.)
5 x 2.54 x 2.54 cm

Resin capsule rings, 2017
resin, mixed media, Shrinky Dinks
Approx. 2.5 cm

Bum bear figurine 1 of 10, 2016
made in collaboration with Phil Woollam
resin and paint
12.7 x 7.62 x 7.62 cm

Wood and resins:
Watermelons, 2015-19
wood, paint, resin
various sizes

Kitten in new sneaker, 2018
acrylic on wood
10 x 7.6 x 1.2 cm

Cat in basket, sleeping cat with butterfly, but-
terfly on flower, 2017
acrylic, mixed media, resin
7.62 x 7.62 x 5 cm (drips)

Shiny volcano cat, 2017
wood, acrylic paint, resin, mixed media
20.32 x 19.05 x 1.27 cm

Purple heart, 2013
wood, paint, googly eyes, resin
2.5 cm square

Polymer clay (Sculpey) figurines and brooches:
Chapter titles, 2015
Sculpey and gouache
Approx. 2.5 cm square or smaller, each

Shy guy in cave, white squirrel, 2014, 2016–
present
Sculpey, paint, jewel, resin

Prototype of perfect cat, 2014
Sculpey, paint
5 x 2.54 x 2.54 cm

Tiger boy, 2013
found cat figurine, house paint, acrylic, Sculpey
10 x 7.6 x 5 cm

Blacklight Mushroom Mega, 2012
Sculpey and ink
2.5 cm square

Miniature cat in a miniature volcano, 2012
Sculpey and acrylic

Tack Head, 2012
Sculpey and ink
Approx. 2.5 cm square

Pink Poop Bead on a String, 2011–present
Sculpey, pen and ink

Mushroom Bead on a String, 2011–present
Sculpey, pen and ink

Watercolour and inks on paper:
Curious squirrel, sleeping cat with butterfly,
sprouting flower, 2015–16
watercolour paper, inks
15 x 15 cm and smaller

Zines:
pin ups 2
Dogs, doggies, pups and puppies
Untitled (Look Look Look)
keyhole
My colouring book
Lumpies on parade
Regard ici
Untitled (triangle)
All of my stickers
Sticker Album zine
mini-zines-4
summer sketchbook, 2019 (reproduction)

Lady peeper pencil sharpener, 2017
found plastic pencil sharpener, sticker paper,
resin, mixed media
3.81 x 5.08 x 1.27 cm

Selected faces from 160 faces pin-back but-
tons, 2016
pin-back buttons

*Bum Bear Ladies doing Stretches in front of
the Diamond*, 2009
found wood, epoxy, spray paint, acrylic
13.97 x 10.16 cm

NESS LEE
And now, to see what I feel, 2019
acrylic on plywood
243.8 x 275 cm
Courtesy of the artist and Patel Gallery

HARTLEY LIN
Excerpts from *Young Frances* (pages 54–55,
69–71), 2018
ink on Bristol board
35.56 x 27.94 cm, each

GRAEME MacKAY
April 3, 2019, 2019
pen and ink
31.75 x 48.26 cm

December 24, 2012, 2012
pen and ink
43.18 x 35.56 cm

April 10, 2008, 2008
digital print from pen and ink
27.94 x 21.59 cm

Amalgamation octopus cartoon, 1999
pen and ink on paper
35.56 x 43.18 cm

BILLY MAVREAS
Excerpt from *City Face* (3 pages), 2001
ink, Xerox collage on paper, photocopied
27.94 x 21.59 cm, each
Originally published in *The Overlords of Glee*,
Conundrum Press, 2001

Mutra (5 pages), 2003
hand carved rubber stamping
10.2 x 15.2 cm, each

Mutra, 2003
hand carved rubber stamping
photocopy on paper
27.94 x 21.59 cm
Originally published in *Study Group 12* #3, ed.
Zack Soto

RoboBunnies (3 pages), 2005
digital collage, photocopied on paper
27.94 x 21.59 cm, each
Originally published in *Free Radicals*,
ed. Leif Goldberg

Excerpt from unpublished abstract manuscript,
2018–19
photocopies of pen and ink originals
27.94 x 21.59 cm, each

Zines:
Work It Out, 2017
Full colour, for Conundrum Press East Coast
tour
Edition of 100

Pen Jar Test Drawings, 2018
Edition of 30

Untitled Remix Zine, January 18, 2019
(Yellow Cover)
Edition of 10

Untitled Glyph Zine, January 16, 2019
(Blue Cover)
2nd Edition of 20

CAREL MOISEIWITSCH
Oh Canada Our Home and Native Land
(3 pages), 1985
ink drawing on illustration board
50.7 x 38 cm, each
Courtesy of Surrey Art Gallery

Wonder Woman, 1985
ink on board
50.8 x 38.1 cm

SYLVIA NICKERSON
Dream City, 2017–19
mixed media, ink and paint on foamcore,
toothpicks
160 x 213.2 cm

Excerpts from *All We Have Left, Is This*, 2018
watercolour and ink on paper:

Love Always James Street
19 x 26.7 cm

(4 squiggle pages)
21.6 x 23.8, 33 x 20.3, 27.9 x 19.1,
29.2 x 19.1 cm

James Street North (3 pages)
27.9 x 19.1 cm, each

Beautiful Life (3 pages)
27.9 x 19.1 cm, each

The Fear (3 pages)
27.9 x 19.1 cm, 38.1 x 27.9 cm

Revenge Comic (3 pages)
29.2 x 19.1 cm, 38.1 x 29.21 cm

Excerpts from *Creation*, 2016–18
ink on paper:

(pages 16–17)
35.6 x 48.9 cm

(page 20)
38.1 x 28.6 cm

(page 21)
38.1 x 27.9 cm

(page 22)
41.91 x 35.6 cm

(page 23)
38.9 x 27.9 cm

(page 84)
38.7 x 30.5 cm

(pages 85–86, 88)
38.1 x 30.5 cm

(page 87)
38.1 x 27.9 cm

(page 89)
38.1 x 29.2 cm

DIANE OBOMSAWIN
Ici par ici / Here and There, 2006
digital animation, 9 mins
Courtesy of the National Film Board
of Canada

Ici par ici (10 pages), 2003
felt pen, ink and collage
25.4 x 34.93 cm (varying orientation), each

SIMON ORPANA
Excerpt from *The Petrocultures of Everyday
Life* (pages 13–17), 2018
ink and correction fluid on paper
43.18 x 30.48 cm, each

cutout mask from *The Petrocultures of Every-
day Life*, 2018
ink on cut out paper, green Painter's tape,
mounted on black board
38.5 x 31 cm

Simon Orpana and Rob Kristofferson
finals and pencils for excerpt from *Showdown!:
Making Modern Unions* (pages 52–53), 2015
finals: ink and correction fluid on paper
44.45 x 30.48 cm, each
roughs: pencil on card
42.3 x 27.8 cm, each

Excerpt from *Showdown!: Making Modern
Unions*, 2015
colour reproduction
35.4 x 21.6 cm

MEREDITH W. PARK
Hamilton: A City in Transition
(2 pages), 2017
ink, pencil, watercolour
30.48 x 22.5 cm, each
Courtesy of the artist (in partnership
with TrueCity)

15 Sketchbooks, 2013–18:

Houses Moleskine, 2018
pencil crayon, watercolour
40.64 x 13.34 cm

Small Blue AK Cover, 2018
ink, watercolour
13.97 x 17.78 cm

Blue Dagger Book, 2016
pencil crayon, ink, watercolour
27.94 x 13.97 cm

Green and Gold Skull Book, 2016
ink, watercolour
26.67 x 30 cm

Handbound Marble Book, 2016
ink, watercolour
26.67 x 16.51 cm

Donut Stickers Book, 2015
non-photo blue and graphite pencils, pen
29.84 x 21.59 cm

Lake Painting Cover Book, 2015
pen
29.84 x 22.86 cm

Greek Exercises Book, 2014
graphite pencil, pen, pencil crayon
38.1 x 25.4 cm

Green Cranes Book, 2014
graphite pencil and watercolour
27.94 x 8.89 cm

Small Book from Jonathan, 2014
ballpoint pen
22.86 x 14.6 cm

Spring Songs Book, 2014
graphite pencil, pen, marker
38.1 x 25.4 cm

Steady Book, 2014
ballpoint pen
25.4 x 30 cm

Summer + Fall 2013, 2014
pen
38.1 x 25.4 cm

Fall + Winter 2013, 2013
felt-tip pen
38.1 x 25.4 cm

COLE PAULS

Excerpt from *Dakwäkãda Warriors III* (page 9), 2018
ink on paper
33.02 cm x 21.59 cm

Excerpt from *Dakwäkãda Warriors III* (page 22), 2018
ink on paper
33.02 x 21.59 cm

Excerpt from *Dakwäkãda Warriors II* (page 2), 2017
ink on paper
33.02 x 21.59 cm

Dakwäkãda Warriors shirt illustration, 2017
ink on paper
43.18 x 27.94 cm

Excerpt from *Dakwäkãda Warriors I* (page 1), 2016
ink on paper
33.02 x 21.59 cm

Excerpt from *Dakwäkãda Warriors I* (page 6), 2016
ink on paper
33.02 x 21.59 cm

GORD PULLAR

Hamilton Series, 2005–9
brush and ink on heavy bond paper
45.72 x 48.26 cm

Living without Hydro, 2006
#108 Hunt Hawk Quill and Pelikan ink on heavy vellum
27.94 x 21.59 cm

Donut Street (plus tear sheet), 2001
ink, pencil, watercolour and collage
50.8 x 38.1 cm

James Street North (plus tear sheet), 2001
ink, doctored Pigma pen and watercolour illustration board (Bainbridge 80)
50.8 x 38.1 cm

Excerpt from *Shy the Alien Boy* (pages 1–2), 2000
brush and ink on bond paper
43.17 x 27.94 cm, each

MICHEL RABAGLIATI

Excerpt from *Paul au parc* (pages 92–93), 2011
ink on paper
29.21 x 24.13 cm, each

Excerpt from *Paul à Québec* (pages 118–21), 2009
ink on paper
29.21 x 24.13 cm, each

Excerpt from *Paul à la pêche* (pages 46–49), 2006
ink on paper
29.21 x 24.13 cm, each

Excerpt from *Paul dans le métro* (pages 10–11), 2001
ink on paper
29.21 x 24.13 cm, each

R.A. ROSEN

Excerpts from *Flem* (Chapter 1, pages 7–8, 13–14), 2018
ink on board and paper
42 x 30 cm, each

Excerpt from *Flem* (Chapter 2, pages 1–2), 2018
ink on board and paper
42 x 30 cm, each

WALTER SCOTT

I Could Have Moved to New York, but I Believe in Serving My Community. For Now., 2019
vinyl
548.64 x 493.78 cm

Curators Hate Her, 2017
lightbox
83.82 x 58.42 x 20.32 cm

Let's Talk About Validation (2 pages), 2016
ink on paper
20.32 x 27.94 cm, each

Creative States of Being 1 and 2 (2 pages), 2015
ink on paper
20.32 x 27.94 cm, each

Excerpt from *Wendy* (4 pages), 2012
ink on paper
21.59 x 13.97 cm, each

Excerpt from *Wendy* (5 pages), 2012
ink on paper
21.59 x 13.97 cm, each

SETH

House with furniture sculpture, 2017
ceramic
Closed: 14.8 x 22.2 x 28.2 cm
Lid: 13.8 x 21.5 x 26.3 cm
Base: 6 x 21.5 x 28.5 cm
8 furniture pieces of various sizes

The *Clyde Fans* building, 2002
tempera and ink on cardboard
32 x 12.8 x 22.5 cm

Excerpt from *George Sprott: January 15, 1927* (3 pages), 2008
ink and tempera on paper
Approx. 41.5 x 31.5 cm (each unique)

Excerpt from *George Sprott: The White Dream*, 2006
ink on paper
Approx. 51 x 48.3 cm

Excerpt from *Nothing Lasts* (final drawings and roughs), 2016/2017
finals (3 pages): ink and tempera on paper
30.6 x 21.4 cm, each
roughs (3 pages): ink and pencil crayon on paper
43 x 28 cm, each

Excerpt from *It's a Good Life, If You Don't Weaken* (pages 1–4), 1993
ink on paper
57 x 38 cm, each

Excerpt from *Clyde Fans* (pages 31–33), 2017
ink, paper and adhesive on paper
Approx. 50.8 x 34.6 cm (each unique)

Kao-Kuk light, 2015
glazed ceramic, light fixture
34.4 x 19 x 19 cm

Sketchbook #8
28 x 21 x 2.7 cm

Luc Chamberland
The Death of Kao-Kuk, 2015
digital animation, 5 mins
Courtesy of the National Film Board of Canada

JAMES SIMPKINS

WHEN I WAS A CUB, THE WATER WAS ALIVE WITH FISH AND YOU COULD SEE CLEAR TO THE BOTTOM. IT'S NOT LIKE THAT NOW. TEN GUESSES WHO'S TO BLAME, 1971
pen and black ink over pencil with opaque white on wove paper with collaged sections
22 x 38.7 cm
Courtesy of Library and Archives Canada, e011297334
© Estate of James Simpkins

HE'S WAVING SON. WAVE BACK, 1950–68
wash, charcoal and brush/pen with black ink and opaque white on commercial board with collaged sections
28 x 25 cm
Courtesy of Library and Archives Canada, e011297335
© Estate of James Simpkins

HEY! MY SUCKER'S STUCK TO YOUR TUMMY, 1972
pen and black ink over pencil with opaque white on wove paper with collaged photomechanical print
24.3 x 27.5 cm
Courtesy of Library and Archives Canada, e011297334
© Estate of James Simpkins

YOU MAY BE ABLE TO SEE A BEAR FROM THE LOOKOUT, BUT I DOUBT IT, 1965
wash and brush/pen with black ink over pencil on commercial board with collaged wove paper
33.5 x 26.7 cm
Courtesy of Library and Archives Canada, e011297337
© Estate of James Simpkins

FIONA SMYTH
Cheez 606, 2019
pen
21.59 x 27.94 cm

Cheez 502, 2017
pen
21.59 x 27.94 cm

The Walk, 2015
digital animation from 75 pen, ink and brush, and digitally coloured drawings
21.59 x 27.94 cm, each

The Drawing Siphon, 2012
digital animation from 2200 pen, ink and brush drawings
27.94 x 21.59 cm, each
Courtesy of the artist; thanks to the Ontario Arts Council

KNOWS SWONK (6 pages), 2009
ink, acrylic
30.48 cm x 20.32 cm, each

The Woe Begone (8 pages), 2008
acrylic, ink
27.94 x 21.59 cm, each

Pavor Nocturnus (5 pages), 2006
ink and wash, gouache
27.94 x 21.59 cm, each

Fazooza 52, 2000
gouache, ink
27.94 x 21.59 cm

Fazooza 55, 2000
gouache, ink
21.59 x 27.94 cm

Fazooza 47, 1999
gouache, ink
27.94 x 21.59 cm

The Teen Years: Deliverance (6 pages), 1998
brush and ink, gouache
27.94 x 21.59 cm, each

Cheez 51, 1996
brush and ink
21.59 x 27.94 cm

Cheez 8, 1992
brush and ink, gouache
43.18 x 27.94 cm

JILLIAN TAMAKI
Cover drawing for *This One Summer*, 2013
ink on paper
43.18 x 27.94 cm

This One Summer cover
colour reproduction

Excerpts from *This One Summer* (pages 235, 237, 244), 2013
ink on paper
43.18 x 27.94 cm, each

Process pages for *This One Summer* (6 pages), 2013
ink on paper, graphite, printout
43.18 x 27.94 cm, each

Trash the Block (pages 52–57), 2012
ink and acrylic
varying sizes: largest 26 x 28 cm

Trash the Block (2 pages), 2012
colour reproduction

Process pages for *Trash the Block* (4 pages), 2012
graphite on paper
3 pages, 29.5 x 45 cm, each
1 page, 30.5 x 25.5 cm

Pencil drawings for *Skim* (pages 48–57), 2006–7
graphite on paper
29.94 x 21.59 cm, each

MAURICE VELLEKOOP
"Sleeping Beauty," Part 3, Chapter 1, from *I'm So Glad We Had This Time Together* (pages 8–9), 2017
ink and watercolour on paper
55.88 x 38.1 cm, each

"Two Excursions," Part 1, Chapter 1, from *I'm So Glad We Had This Time Together* (pages 23–25), 2014
ink and watercolour on paper
55.88 x 38.1 cm, each

Pop Life, 1992
ink, watercolour, toys, watches, puffy stickers on paper in collaged frame
88.9 x 71.76 cm

KAT VERHOEVEN
Excerpts from *Meat and Bone* (pages 128–30, 268–70), 2017–18
Pentel pocket pen, India ink on bond
34.29 x 26.67 cm, each

ERIC KOSTIUK WILLIAMS
Excerpt from *Hungry Bottom Comics* (2 pages), 2012
pen and ink
38.1 x 55.9 cm, each

Excerpts from *Condo Heartbreak Disco* (5 pages), 2015
pen and ink
38.1 x 27.94 cm, each

CONNOR WILLUMSEN
Finals from *Anti-Gone* (pages 64–65, 68–69, 82–85), 2016
ink and marker on vellum
35.56 x 27.94 cm, each

Pencils from *Anti-Gone* (pages 64–65), 2016
graphite on paper
34.2 x 26.7 cm, each

Excerpt from *Swinespritzen* (pages 14–17), 2014
ballpoint pen on loose leaf
29.21 x 20.32 cm, each

JENN WOODALL
Black Mood (pages 1–2), 2016
ink, watercolour
27.94 x 43.18 cm

DOUG WRIGHT
Nipper and the Cat and Mouse, 1973
pen and black ink on commercial board with acetate overlay
26.2 x 38.5 cm
Courtesy of Library and Archives Canada, e011297331
© Estate of Doug Wright

YAK YAK YAK, 1952
pen and black ink on commercial board with acetate overlay
50.8 x 15 cm
Courtesy of Library and Archives Canada, e011297332
© Estate of Doug Wright

Bring your Head Office to QUÉBEC…, ca. 1977–78
pen and black ink on commercial board with acetate overlay
24.2 x 30.8 cm
Courtesy of Library and Archives Canada, e011314903
© Estate of Doug Wright

"Harold, don't be such a pig…slow down so mother can enjoy the view!", 1966–70
pen and black ink on commercial board with acetate overlay
24 x 29 cm
Courtesy of Library and Archives Canada, e011314904
© Estate of Doug Wright

"I certainly see no harm in the Government investigating art education!", 1966
pen and black ink on commercial board with acetate overlay
24 x 31 cm
Courtesy of Library and Archives Canada, e011314905
© Estate of Doug Wright

Juniper Junction – "Goin' Courtin' Pigskin?", 1949
pen and black ink on commercial board with acetate overlay
28.4 x 58.7 cm
Courtesy of Library and Archives Canada, e011297333
© Estate of Doug Wright

THANK YOU

Peter Birkemoe, Chris Butcher, Andrew Woodrow-Butcher, Annie Koyama, Tom Devlin, Peggy Burns, Julia Pohl-Miranda, Tracy Hurren, Brad MacKay, David Collier, Diana Tamblyn, Andy Brown, Graeme MacKay, Jeet Heer, Galerie Martel, Phil Elverum, Benoit Chaput, Librairie Drawn & Quarterly, Kat Verhoeven, Taien Ng-Chan, Sam Ollmann-Chan, Ryan Sands, Surrey Art Gallery, Reactor Art & Design, Library and Archives Canada, Howard Elliot, Sandy Boyle, Phyllis Thomas, Melissa Bennett, Ella Shepherd, Drawn & Quarterly, RM Vaughan, Rhys Edwards.

Published in conjunction with the exhibition **THIS IS SERIOUS: Canadian Indie Comics**.
Organized by the Art Gallery of Hamilton and presented in Hamilton from 21 June 2019 – 5 January 2020.

Curators: Joe Ollmann, Alana Traficante
Authors: Peggy Burns, Shelley Falconer, Jeet Heer, Joe Ollmann, Alana Traficante
Editors: Meg Taylor, Alana Traficante
Copy Editors: Andy Brown, Tobi Bruce, Melissa Neil, Tara Ng, Alana Traficante
Exhibition and publication coordinator: Melissa Neil
Designer: Joe Ollmann
Printing and Binding: Gauvin, Gatineau, Quebec

Images: Drawn & Quarterly: Kate Beaton, Chester Brown, Geneviève Castrée, Julie Delporte, Aminder Dhaliwal, Julie Doucet, Sylvia Nickerson and Seth. Reactor Art + Design: Maurice Vellekoop. Robert McNair: Installation photography for Ginette Lapalme and Ness Lee.

Cover page: Julie Doucet, *A Day in Julie D.'s Life*, 1990, ink on Bristol board. Courtesy of the artist.

Library and Archives Canada Cataloguing in Publication

Title: This is serious : Canadian indie comics / edited by Alana Traficante & Joe Ollmann.

Other titles: Canadian indie comics

Names: Traficante, Alana, 1981- editor. | Ollmann, Joe, 1966- editor. | Art Gallery of Hamilton (Ont.),

 host institution, publisher.

Description: Published in conjunction with an exhibition held at the Art Gallery of Hamilton from

 June 21, 2019 to January 5, 2020.

Identifiers: Canadiana 20190134569 | ISBN 9781897407301 (softcover)

Subjects: LCSH: Comic books, strips, etc—Canada—Exhibitions. | LCSH: Cartoonists—Canada. | LCSH:

 Artists—Canada. | LCGFT: Exhibition catalogs.

Classification: LCC PN6732 .T55 2019 | DDC 741.5/6971—dc23

Published to the book trade by Conundrum Press. Wolfville, NS. www.conundrumpress.com
Distribution in Canada by Litdisto.
Distribution in USA by Consortium Book Sales & Distribution.
Distribution in UK and International by Ingram Publisher Services International.
Conundrum Press acknowledges the financial support of the Government of Canada and the Province of Nova Scotia.

Art Gallery of Hamilton
123 King Street West
Hamilton, Ontario
Canada L8P 4S8

Conundrum Press
Wolfville, Nova Scotia

Hamilton

ONTARIO ARTS COUNCIL
CONSEIL DES ARTS DE L'ONTARIO
an Ontario government agency
un organisme du gouvernement de l'Ontario

Canada Council for the Arts **Conseil des Arts du Canada**